Controversy and Hope

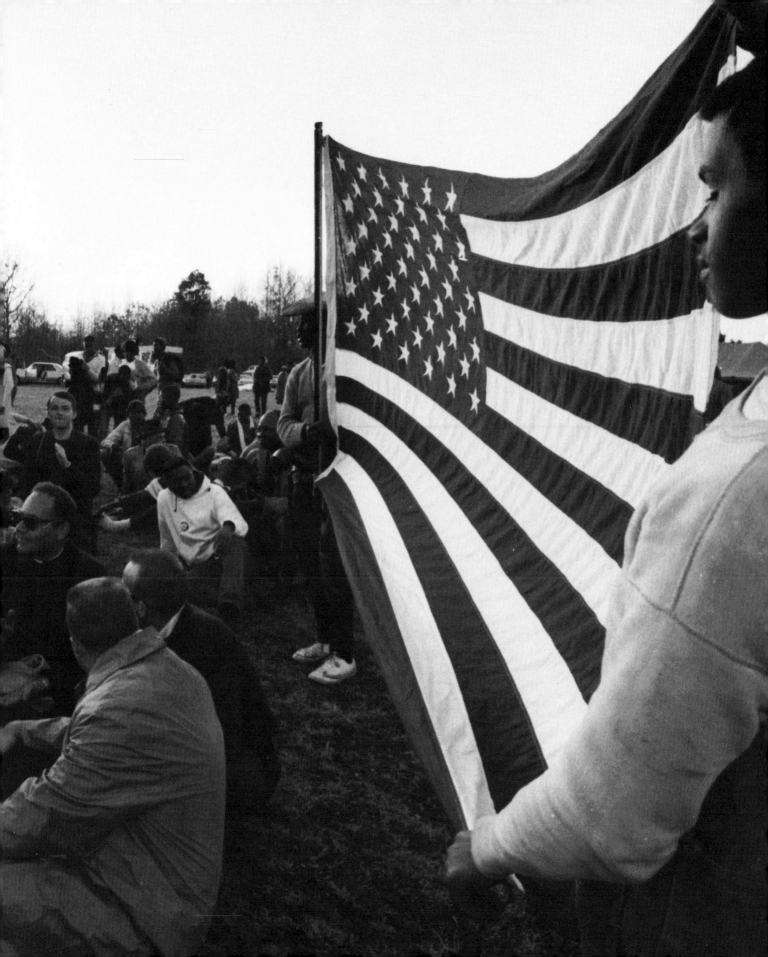

CONTROVERSY AND HOPE

The Civil Rights Photographs of James Karales

JULIAN COX

With Rebekah Jacob and Monica Karales

Foreword by Andrew Young

THE UNIVERSITY OF SOUTH CAROLINA PRESS

*in cooperation with the Estate of James Karales
and Rebekah Jacob Gallery, Charleston*

© 2013 University of South Carolina

Published by the University of South Carolina Press
Columbia, South Carolina 29208

www.sc.edu/uscpress

Manufactured in the United States of America

22 21 20 19 18 17 16 15 14 13
10 9 8 7 6 5 4 3 2 1

Library of Congress Cataloging-in-Publication Data
Karales, James H., 1930–2002, photographer.
 Controversy and hope : the civil rights photographs of James Karales / Julian Cox with Rebekah
 Jacob and Monica Karales ; foreword by Andrew Young.
 p. cm.
 Includes bibliographical references.
 ISBN 978-1-61117-157-0 (hardbound : alk. paper) — ISBN 978-1-61117-158-7 (pbk. : alk. paper)
1. Karales, James H., 1930–2002—Catalogs. 2. Civil rights movements—United States—History—20th
century—Pictorial works. 3. African Americans—Civil rights—History—20th century—Pictorial works.
4. King, Martin Luther, Jr., 1929–1968—Pictorial works. 5. Selma to Montgomery Rights March (1965 :
Selma, Ala.)—Pictorial works. I. Cox, Julian, editor of compilation. II. Title.
 E185.615.K287 2013
 323.092—dc23
 2012038659

Frontispiece: Marchers Settling at Camp, Selma to Montgomery March, 1965, plate 64 (detail).

This book is dedicated to the photographer's four sons—
Joseph, James, Alexandros, and Andreas—with the hope
that this legacy will extend to future generations.

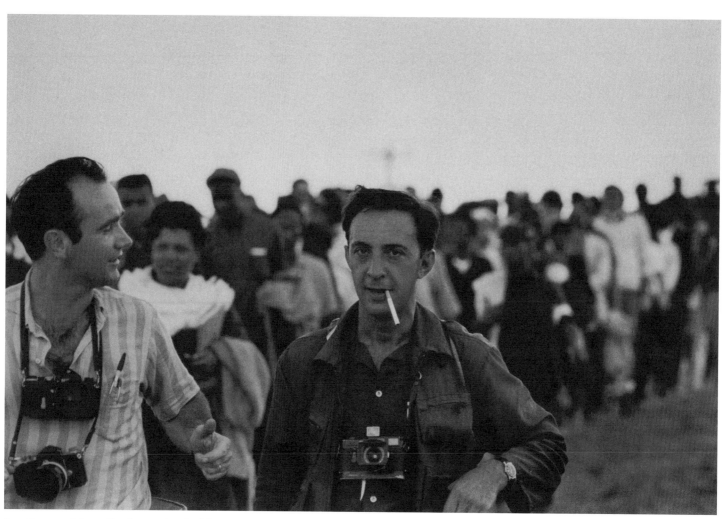

Sam Castan and James Karales covering the Selma to Montgomery March for Voting Rights, 1965.
Photographer unknown. Estate of James Karales.

Contents

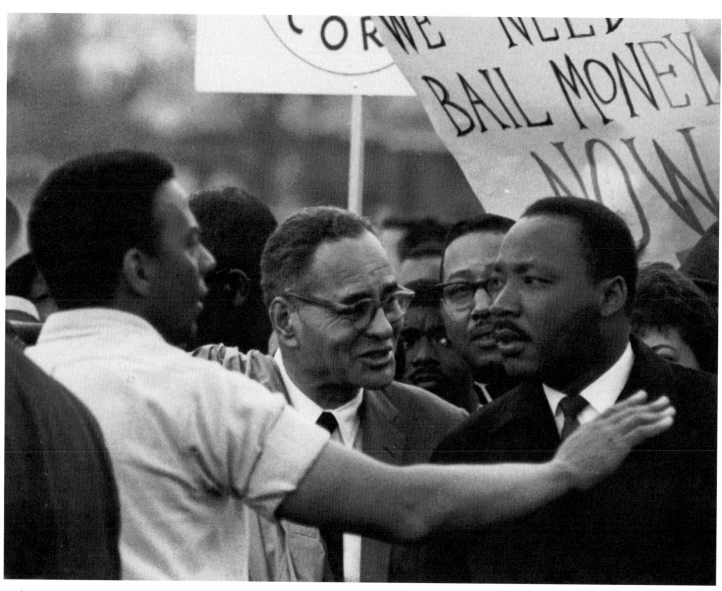

Andrew Young Speaking to Ralph Bunche and Dr. Martin Luther King, Jr.,
Selma to Montgomery March, 1965, plate 79 (detail).

Foreword

Andrew Young

I am incredibly grateful for this collection of civil rights photographs by James Karales. Many of these images pricked the conscience of the nation and were critical to the success of our struggle. It is no exaggeration to say that absent the cameras, we would have marched in vain. In fact we marched and staged demonstrations to create dramatic images for the cameras. It took talent, commitment, understanding, and courage to produce images of our movement that communicated to the world the justness of our cause.

I don't know why James Karales had the sensitivity to capture the power and the humanity of our movement. Perhaps it was a sensibility derived from his life as the child of immigrants. Perhaps it was his immersion in the integrated coal-mining community of Rendville, Ohio. Somehow he was not blinded by the color consciousness that was the hallmark of the segregated way of life we were challenging. Through the lens of his camera, Karales recorded the humanity of a people struggling to be free and conveyed that reality to the nation.

It took real courage to make these images in the face of so much violence. During the Selma to Montgomery March, we had to be protected by the National Guard. Nothing would have prevented a sniper from picking off marchers or photographers. During the Freedom Rides, terrible beatings were directed at white photographers and cameramen not just the nonviolent students trying to integrate interstate transportation.

Karales captured images of the preparation that preceded our demonstrations— the mass meetings and the training in nonviolent social action. He revealed the complexity of emotions intertwined with the hope and hardships of the struggle. He did not flinch from showing the anger and resentment to our freedom movement in the white community.

This is for me a personal collection comprising some of my dearest friends and most valued colleagues. There is an almost prescient photograph of me with Ralph Bunche (plate 79), the deputy secretary general of the United Nations, and photographs of Rabbi Abraham Heschel (plates 46–47), an intellectual mentor. I treasure

the photographs of Martin with his family (plates 20–25). This is a tender side of him the public seldom sees. This volume includes so many stalwarts of the movement who are no longer with us—Martin and Coretta, James Orange, Ralph Abernathy, Hosea Williams, and Rosa Parks. For the survivors—John Lewis, C. T. Vivian, Dorothy Cotton—we see documented some of the triumphs of our early careers.

I am reminded of the celebrities who were committed to this cause. Harry Belafonte was an invaluable supporter of Martin and the movement. He also launched my career in Congress. Harry, Dick Gregory, Jackie Robinson, and Joan Baez used their stardom to expand justice and opportunity for others. They are depicted here, away from the bright lights, standing with the suffering.

This was the pinnacle of the struggle to transform America and free our nation from the ills of racism, war, and poverty. We did transform America on race. Race and color are no longer the absolute barrier that they were under segregation. Our grandchildren are growing up in a nation without segregation, where a person of African descent can rise to lead a Fortune 500 corporation or an Ivy League college, to occupy a seat on the Supreme Court or ascend to the presidency of the United States.

The struggle has changed but not ended. As Martin would say, "Injustice anywhere is a threat to justice, everywhere." As long as people anywhere are judged by race, color, or creed, as long as there is war, as long as there is poverty, we must continue to march, literally and figuratively.

This collection of photographs serves as memory and inspiration—that a small group of dedicated people can transform a nation. I hope it will inspire the reader to take up the challenges of this time.

Preface

Rebekah Jacob

To have studied and explored the archive of the renowned civil rights photojournalist James Karales has been a lifetime's privilege. With my sincere gratitude to his beloved Monica, the devoted steward of this archive, I have been allowed the honor of sifting through thousands of contact sheets, work prints, mounted photographs, notes, and magazines still marked by his fingerprints. Although we never met, I have come to know the greatness of a man revealed both by what he recorded and by what was left unsaid.

I first immersed myself in these treasures in preparation for the exhibition *1968: Controversy and Hope / Iconic Images by James Karales,* organized for the Rebekah Jacob Gallery in the spring of 2009. Karales was a lifelong and avid photographer. Woven throughout his oeuvre of photo-essays is his trademark compassion for social injustice and eye for political upheaval, whether on the Lower East Side of Manhattan, in Vietnam, in the integrated mining town of Rendville, Ohio, or during the turbulent years of the civil rights movement. The civil rights story offered perhaps the richest materials to mine for a book.

The modest Karales only occasionally printed his work and rarely presented it in exhibitions or publications beyond the initial assignment for which it was created. Delving into his meticulously preserved archive, Monica and I joined forces to share Karales's voice with a larger audience, focusing on the period 1960–65. Together with Julian Cox, we spent two years editing and sequencing more than 2,000 images to arrive at a final selection of 93 plates. A modest percentage of the images included in this book were published in *Look* magazine, and some have since been reproduced in books and magazines, but the majority have never been exhibited or published. Our extensive research also included the study of vintage prints in museum collections, the Karales Archive in the Rare Book, Manuscript, and Special Collections Library at Duke University, and a thorough review of the *Look* archives at the Library of Congress. Photographs consigned from the Howard Greenberg Gallery in New York City and the Rebekah Jacob Gallery in Charleston, South Carolina, were also

vital resources. Recollections shared by Karales's contemporaries Tony Vaccaro, Bob Adelman, Steve Schapiro, Matt Herron, and Paul Fusco added an invaluable human dimension to the project.

The 1960s were the heyday of the great photography magazines, providing working photographers with the opportunity to capture the spirit of the time in elaborate, multipage spreads with large images. Civil rights leaders embraced the medium as a vehicle to inform and educate the general public and as a means to document their momentous journey. Magazines were hungry to print images from the front lines. Despite the dangers for journalists, photographers were drawn to the drama of the civil rights story and provided valuable witness to the demonstrations, arrests, riots, and burnings.

With several cameras slung around his neck and a cigarette in one hand, Karales focused his intense gaze on one of the most challenging issues in our nation's history. He balanced the job's requirements with his own aesthetic to find a different story, one of tenderness and triumph. Within the crowds his discerning eye discovered heroic portraits of individuals, such as a teenage boy enveloped by a massive, hand-stitched flag (plate 76), or a youth with "vote" emblazoned across his forehead (plate 59).

Arguably the most significant work of this time comes from Karales's close access to Dr. Martin Luther King, Jr., and other key civil rights leaders. One of only a few photographers to enter King's home, Karales created images of Dr. King that go beyond the expected to portray quiet, telling moments. One photograph reveals Dr. King's fatherly angst as he painfully broke the news to his young daughter that she was forbidden to visit an amusement park because of her race (plate 24). The caption in the February 12, 1963, issue of *Look* reads: "I told my child about the color bar."

The photographs in this book present the full range of civil rights assignments that Karales undertook in the years 1960–65: nonviolent passive resistance training in Atlanta in 1960; the Southern Christian Leadership Conference (SCLC) convention in Birmingham in 1962; an intimate series of the King family at home in Atlanta in 1962; Dr. King and Rev. Ralph Abernathy's campaign in Birmingham in 1962, which includes pictures made in the Sixteenth Street Baptist Church, with the Rev. C. T. Vivian, Rosa Parks, and other leaders in attendance. The story concludes with a selection of images documenting the Selma to Montgomery March for Voting Rights in 1965, which provided the culminating and iconic images of a movement that had become so personal for Karales.

Despite the passage of time, or perhaps heightened by it, we are able to see the integrity and clarity of Karales's vision against the backdrop of a crucial juncture in our shared history. His work continues to compel us to remember both what divides us and what unites us. It is my hope that this publication reveals previously untold moments in this pivotal era of American history.

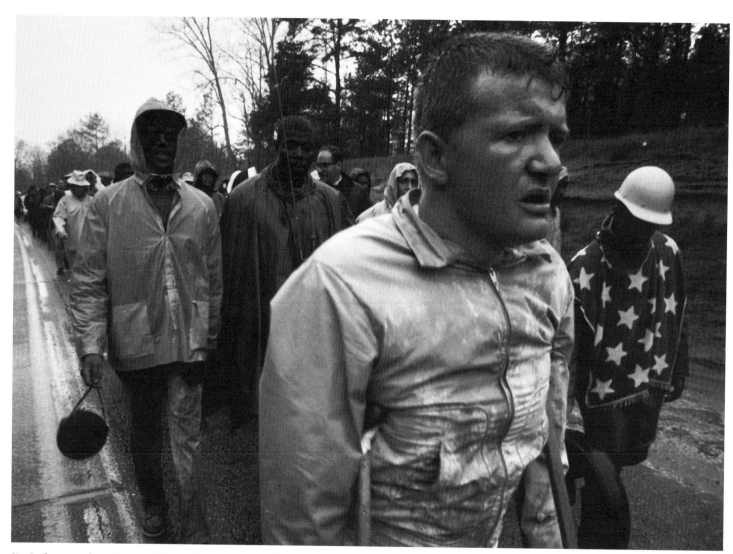

Jim Letherer Leading Marchers, Selma to Montgomery March, 1965, plate 73 (detail).

Acknowledgments

Each new project carries with it the unique imprint of many people who contributed the intellectual and emotional support that made it possible. *Controversy and Hope: The Civil Rights Photographs of James Karales* is the result of an extraordinary confluence of personalities, talents, and ideas.

We are humbled and honored by the contribution of Ambassador Andrew Young, whose words prove to be as stirring and inspirational as his deeds. We are also most grateful to Karales's contemporaries—Paul Fusco, Tony Vaccaro, Bob Adelman, Matt Herron, Will Hopkins, and Steve Schapiro—whose friendship, interest, and support have been invaluable to the development of this book. They have contributed in a significant way to the civil rights movement through their own creative voices, and we salute them.

We are especially thankful to many colleagues for their special efforts to provide us with information about Karales and his photographs—particularly Karen Glynn, Robert Byrd, and Richard Armacost at Duke University; Howard Greenberg, Karen Marks, Ali Price, Margit Erb, and Harvey Robinson at the Howard Greenberg Gallery; James Danziger at Danziger Projects; Brett Abbott and Rachel Bohan at the High Museum of Art, Atlanta; and Dan Leers at the Museum of Modern Art, New York. We greatly appreciate the technical contributions of photographers Rick Rhodes and David Edwards. And we are grateful for the support provided by the dedicated and skilled staff at the Rebekah Jacob Gallery, in particular Samantha Abrams.

The goodwill and generous counsel of friends and family has been inspiring. In particular we appreciate the dedication to this project given by Dr. John Palms and Dr. Virgil Alfaro. We also wish to thank the photographer's family, his brother Nikos Karales and the photographer's four sons: Joseph, James, Alexandros, and Andreas. Finally our sincere gratitude goes to William Stepanek for his warm and unfailing support during the preparation of this manuscript.

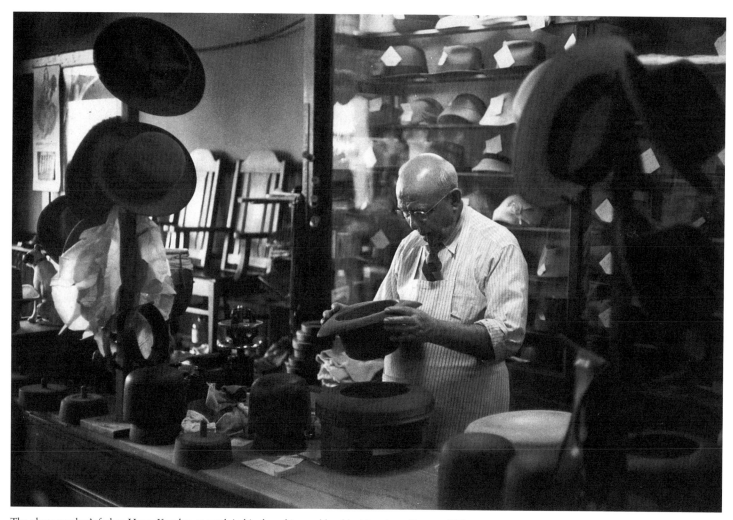

The photographer's father, Harry Karales, at work in his shoe-shine and hat-blocking shop, Canton, Ohio, 1953.
Photograph by James Karales. Estate of James Karales.

Chronology

1930

James Harry Karales is born on July 15, in Canton, Ohio, to Harry and Maria Karales. Greek is his first language, and he goes by the Greek version of his name, Dimitrios.

1949

Graduates from Timken Vocational High School, Canton, Ohio, with skills in metalwork, welding, and electrical engineering.

1950–52

Works as a machinist at the Timken Roller Bearing Company, Canton, Ohio.

1953

Enrolls at Ohio University, where he studies photography under Betty Truxell and Walter Allen. Begins an extended photo-essay documenting Greek American life in Canton, Ohio, and including other communities in the Midwest. Also initiates an extended photo-essay documenting the mining town of Rendville, Ohio.

1954

Enlists in the U.S. Naval Reserve, serving until October 1958.

First one-man show of 105 photographs is held at the Canton Art Institute, Canton, Ohio.

First photo-story, "Girls Football Game at Ohio University, Athens, Ohio," is published in the November 14 issue of *Sports Illustrated*.

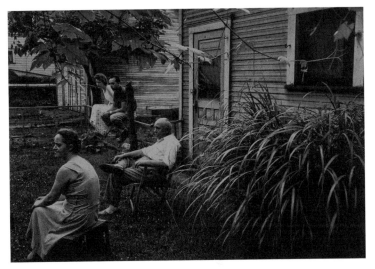

The Karales family at home in the garden, Canton, Ohio, 1953. Photographer unknown. Estate of James Karales

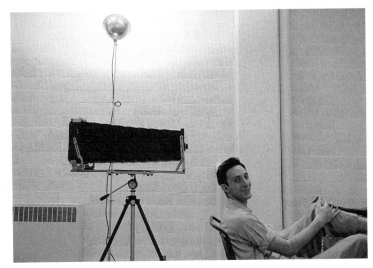

James Karales in the studio at Ohio University, 1954. Photographer unknown. Estate of James Karales.

A photograph from Karales's Oregon logging series, 1958–59. Estate of James Karales.

1955

Produces an extended photo-essay on the Lakin Boys Industrial School in Lakin, West Virginia, a progressive reform school for delinquent African American boys.

Graduates from Ohio University.

His photo-story "Ohio Sub Hunters," about the U.S. Navy Reservists of Akron, Ohio, and their training in Norfolk, Virginia, is published in the August 21 magazine section of the *Cleveland Plain Dealer*.

Moves to New York City in search of career opportunities.

Meets Edward Steichen.

Two of Karales's photographs are acquired by the Museum of Modern Art, New York.

John Morris at the Magnum photo agency provides an introduction to W. Eugene Smith, for whom Karales works as an assistant for more than two years.

1956

An article on Karales, "A Photographer Who Brought His Picture to Life," is published in the March issue of *Modern Photography*.

1957

Photo-essay "The Greeks of Canton" is published in the January issue of *Jubilee*.

Marries Eleanor Anne Cecilia Francis on September 28.

1958–59

Works as a freelance photographer, including contract work for the architectural firm Perkins & Will. Produces a photo-essay on the logging and lumber industry in Oregon.

1959

First son, Joseph, is born December 8.

Exhibits photographs from the Rendville project at the Limelight Gallery in New York City.

1960

Joins the staff of *Look* magazine, where he works until 1971.

In May travels to Atlanta, Georgia, to photograph passive resistance training organized by the Student Nonviolent Coordinating Committee (SNCC).

In December takes photographs for an unpublished story on segregation in New York City.

1961

Second son, James, is born June 11.

Receives a National Urban League certificate of recognition for photographic excellence for his participation in *America's Many Faces*, an exhibition designed to show the multiracial character of America.

"Report from [Gheel] Belgium: A Town That Cares for the Mentally Ill," is published in the May 23 issue of *Look* with photographs by Karales and text by Roland H. Berg.

Visits family in Athens, Greece.

1962

Has extensive contact with Dr. Martin Luther King, Jr., photographing him in Birmingham, Alabama, and Atlanta, Georgia.

1963

"A Visit with Martin Luther King," is published in the February 12 issue of *Look* with photographs by Karales and text by Ernest Dunbar.

"Victims of Welfare," is published in the March 26 issue of *Look* with photographs by Karales and text by Sam Castan.

Makes first trip to Vietnam, working closely with Castan.

1964

"What Johnson Faces in South Vietnam" and "Vietnam's Two Wars" are published in the January 28 issue of *Look* with photographs by Karales and texts by Castan.

"James Bailey, M.D." is published in the December 15 issue of *Look* with photographs by Karales and text by Betty Dietz.

1965

Covers the Selma to Montgomery March for Voting Rights, March 21–25.

Visits Vietnam for the second time.

"Vietnam: Washington's Biggest Problem" and "Recollections from a Notebook in Vietnam" are published in the April 6 issue of

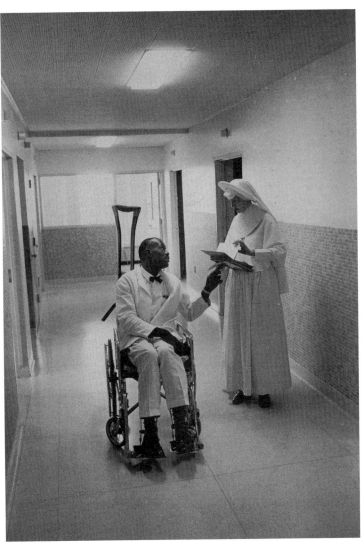

One of Karales's photographs of Dr. James Bailey, 1964. Estate of James Karales.

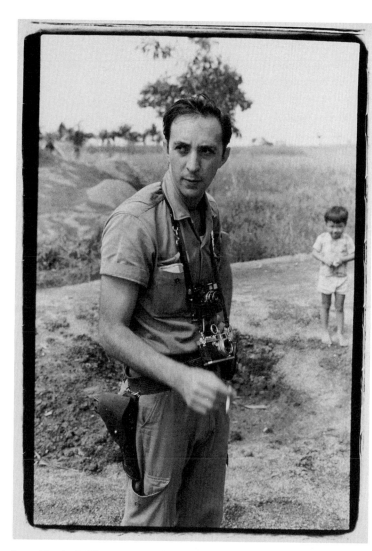

James Karales in Vietnam, 1965. Photographer unknown. Estate of James Karales.

Look with photographs by Karales and text by Castan.

"Our Churches' Sin Against the Negro" and "Turning Point for the Church" are published in the May 18 issue of *Look* with photographs by Karales and text by Christopher Wren.

Receives the Missouri School of Journalism's Pictures of the Year Award, First Place Magazine News, for the Selma March essay.

Exhibition at Leitz Gallery, New York City.

1966

"Saigon: Stained Pearl of the Orient" is published in the May 17 issue of *Look* with photographs by Karales and text by Castan.

Receives a New York Art Directors Club Certificate of Merit for the photo-essay "Turning Point for the Church."

"Father Tom Confroy: Church Is in His Combat Pack" is published in the July 12 issue of *Look* with photographs by Karales and text by Castan.

1967

"Drugs and Mysticism: The Visions of 'Saint Tim'" is published in the August 8 issue of *Look* with photographs by Karales and text by J. M. Flagler.

1968

Awarded a New York Art Directors Club Certificate of Merit at their forty-eighth annual exhibition.

1969

Awarded a New York Art Directors Club gold medal, at their forty-ninth annual exhibition.

1970

Begins a photo-essay on the Lower East Side of New York City, continuing work on it through 1973.

"Lament for a Lost Revolution" with photographs by Karales and text by Leonard Gross and "Never Gonna Be a Country Boy Again" with photographs by Karales and text by Tom Smothers are published in the February 24 issue of *Look*.

The Overseas Press Club of America presents its Citation for Excellence to Karales for the photo-essay "The Germany We Don't Know," published in the June 16 issue of *Look* with photographs by Karales and text by J. Robert Moskin.

1971

"A High School Fights for its Life . . . and a Principal for His," about George Washington High School in Denver, is published in the March 9 issue of *Look* with photographs by Karales and text by Leonard Gross.

"Get Me an Ax!" is publish the June 29 issue of *Look* with photographs by Karales and text by William J. McKean.

The last issue of *Look* is published on October 19.

Exhibits photographs at the Nikon Gallery, New York City.

1973

Seeking a Guggenheim Fellowship, Karales produces a book dummy for "East Seventh Street between Avenues C and D," with fifty-four photographs and text by Father Bruce Ritter, a Franciscan priest who established the Covenant House for runaway teenagers.

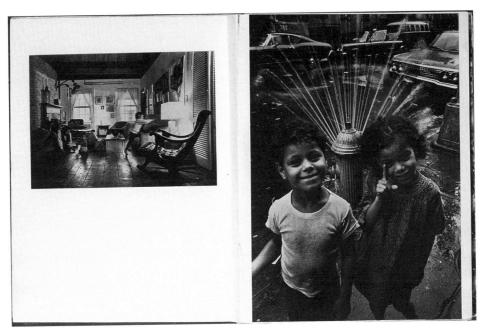

Pages from book dummy for Karales's unpublished "East Seventh Street between Avenues C and D," 1973. Estate of James Karales.

1975

Marries Monica Poltera, October 11.

1977

Third son, Alexandros, is born April 15.

1979

Fourth son, Andreas, is born November 6.

1980

Exhibits photographs at the Rizzoli Gallery, New York City.

1983

"Tex Mex Towns: A Taste of Mexico Just Across the Rio Grande" is published in the October issue of *Diversion* with photographs by Karales and text by Patrick Weir.

1994

Photographs are included in *Appeal to This Age: Photography of the Civil Rights Movement, 1954–1968,* an exhibition at the Howard Greenberg Gallery, New York City.

1999

A solo exhibition, *James Karales: Witness,* is presented at the Howard Greenberg Gallery.

2000

Awarded the Westchester Arts Council Artist of the Year Award, Rye, New York.

2002

Dies of cancer on April 1, in Croton-on-Hudson, New York, at the age of seventy-one. Obituary published in the April 8 issue of the *New York Times.*

2006

A retrospective exhibition, *James Karales, Photojournalist,* is presented at the Kennedy Museum of Art, Ohio University, Athens, Ohio.

2007

The National Endowment for the Humanities (NEH) selects one of Karales's Selma March photographs (plate 53) as one of forty images in the "Picturing America" program.

2009

A solo exhibition, *1968: Controversy and Hope/Iconic Images by James Karales,* is presented at Rebekah Jacob Gallery, Charleston, South Carolina.

Controversy and Hope

Living Testimony
James Karales and the Quest for Civil Rights

Julian Cox

For the news media and for photographers, the civil rights movement was an engaging, demanding, and sometimes highly dangerous story. An array of photographers—artists, photojournalists, movement activists, and amateurs—made historic and perspective-changing images of this tumultuous era in American history, and each had a distinct point of view. While their respective approaches may have differed, they all seem to have recognized the significance of the moment, and they understood that they were documenting a nation in transition. As Steven Kasher has put it, "The great photographs of the movement were crafted with urgent passion—for their own time and for the future."[1] Sometimes profoundly, these photographs transcend their primary identity as social documents and exist as forceful evidence of the seriousness of a problem that millions of citizens chose to ignore or deny. They may also show us something that we have not seen before—a point of view that prompts us to look at the subject with renewed concentration.

Many acts of courage were undertaken in the pursuit of freedom—acts that were often photographed, leaving behind a disquieting visual record of this turbulent era. The best photographs of the civil rights movement provide glimpses of hope and unity and suggest a collective determination to stand up and move forward in the face of seemingly impenetrable obstacles. James Karales, a photojournalist trained to record newsworthy events with an objective and informing eye, produced many such photographs. One in particular is etched in history. It shows a column of marchers walking in step against a dramatic backdrop of ominous, storm-brewing clouds on the Selma to Montgomery March for Voting Rights in the spring of 1965 (plate 63).

Faces in the Crowd, Selma to Montgomery March, 1965, plate 42 (detail).

This picture is arguably *the* iconic image of the civil rights era, as yoked to its subject as Dorothea Lange's *Migrant Mother* (1936) is to the struggles of the Great Depression.[2] Ironically the prominence of this one Karales photograph seems to have hindered the recognition of his much broader commitment to the civil rights story, which he demonstrated in a sustained series of assignments for *Look* magazine during the 1960s. By the time Karales undertook his first civil rights assignment for *Look* in the spring of 1960, his formal education and extensive prior experience as a photographer working in the field had prepared him to bring a distinct and well-honed perspective to the civil rights beat.

Starting Out

James Harry Karales was born on July 15, 1930, in Canton, Ohio, the first son of blue-collar Greek immigrants. His father, Harry, had immigrated to the United States in 1903 at the age of eighteen and settled initially in Pittsburgh. Within two years he had moved to Canton, where he earned a living as a factory worker. But his ties to his native country remained strong, and in 1912 he enlisted to fight in the Greek army against Turkey. After two years he returned to Canton and continued working in a factory until 1926, when he started a shoe-shine business. When Harry Karales decided the time was right to marry, arrangements were made for him to meet Maria Katsoulis, from his village in the mountainous interior of the Peloponnese. She came from a working-class family and was one of seven children. Harry and Maria met in Marseilles in 1929 and were married in the Greek Orthodox Church there before sailing for the United States on the SS *Mauritania*.[3] Less than a year later, James was born.

James Karales went by his Greek name, Dimitrios, and was a below average student in junior and high school. He excelled in sports but performed poorly in his classes, mostly because his spoken and written English was weak.[4] As he matured, he showed some aptitude for technical subjects and the sciences and was enrolled at Timken Vocational High School in Canton. The school's yearbook for 1947 describes its mission as the "production of skillful and competent workers to operate America's ever-progressing industries."[5] After graduating in 1949 Karales worked for two and a half years in the Timken Roller Bearing Company, becoming thoroughly bored by the monotony of the labor and the prospect of a career in manufacturing. Consequently he changed course and in 1953 entered Ohio University in Athens, Ohio, to study electrical engineering. As a freshman undergraduate, he discovered photography. Enthused by the activities of the university camera club, he transferred

to the fine arts college, where he studied with Clarence White, Jr., son of the noted Pictorialist-era photographer. Karales's arts education included foundation-level classes in art history, for which he produced extended essays on artists as diverse as Peter Paul Rubens, John Constable, Vincent Van Gogh, and Amedeo Modigliani.[6] Karales's earliest work in photography showed great promise. He trained his camera on subjects that were close at hand, producing formally elegant, rigorous compositions of barns and vernacular structures in rural Ohio. The work was modernist in approach and technically flawless, but it lacked a humanistic bent. That changed when Karales decided to photograph the Greek American community where he grew up. He dedicated more than a year to the task of creating a nuanced record of the social mores, traditions, and community gatherings that were part of his family life in Canton and its environs. When he embarked on the project, Karales had already absorbed one of Edward Steichen's key working principles: "When a photographer makes a series or sequence of pictures about an event, a place, a person, his basic qualities of sensitivity, perception and understanding are more apparent than they are in a single picture."[7]

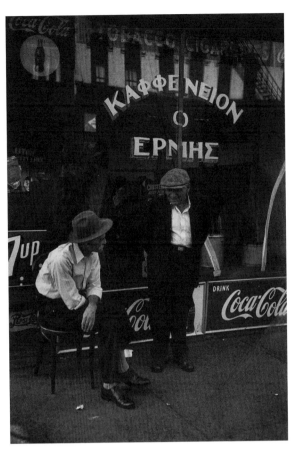

Hermes Coffee House, Canton, Ohio, 1953
6 7/16 × 4 5/16 inches (16.4 × 11.1 cm)
Vintage gelatin silver print
Estate of James Karales

The Canton photographs show Karales's genuine interest in his subject, his keen eye for detail, and the beginnings of his distinct personal vision of the world. They also support his stated intention that the project should "explore the influences of environmental changes and time advance upon the lives of Greek people living in America."[8] The series includes the documentation of services at the Greek Orthodox church in Canton, Ohio, and its Sunday school program. Karales photographed with 35mm and 2 1/4-inch medium-format cameras, generating several dozen contact sheets and proof prints. An expansive selection of 105 photographs from the series was shown at the Canton Art Institute in 1954, the first public exhibition of his work.[9] For a student barely past his freshman year, it was a significant achievement. In addition to this and other ambitious personal projects, Karales also had more mundane photojournalistic

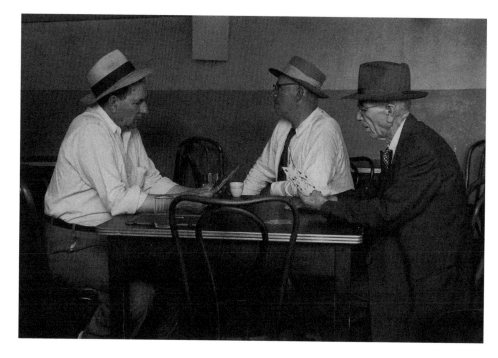

Card Playing,
Hermes Coffee House,
Canton, Ohio, 1953
4 ³/₁₆ × 6 ⁵/₁₆ inches
(10.6 × 16.2 cm)
Vintage gelatin
silver print
Estate of James Karales

assignments. He shot sports events on the campus of Ohio University and completed a photo-story on the training of Naval Air Reservists, which was published in the *Cleveland Plain Dealer* just after he graduated from Ohio University with a B.F.A. in photography in the summer of 1955.[10]

Capturing Community

Not long after he began his examination of the Greek American community in Canton, Karales initiated another in-depth photo-essay, this one on the once prosperous and fully integrated coal-mining town of Rendville in Perry County, Ohio. Tucked into the Hocking River Valley, the community had been an important stop on the Underground Railroad during the Civil War. William P. Rend, a Chicago industrialist and owner of the Ohio Central Coal Company, founded Rendville in 1879. Traditionally the mining industry in the Midwest did not hire African American workers, but Rend employed them in large numbers to labor alongside central and eastern European immigrants. Despite initial racial tensions, Rendville grew quickly, and by 1884 there were nearly three hundred African American residents. The community hosted an Emancipation Day celebration every year to commemorate Abraham

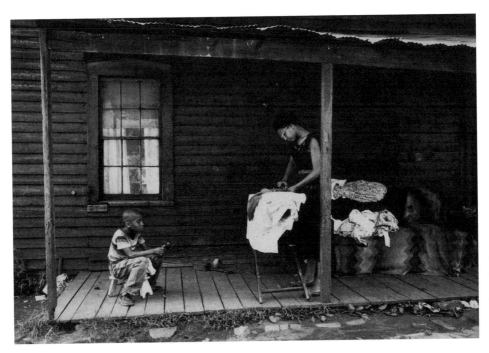

Rendville, Ohio, 1953–55
4³⁄₈ × 6⁷⁄₁₆ inches
(11.1 × 16.5 cm)
Vintage gelatin
silver print
Estate of James Karales

Lincoln's ending of slavery in the South. Adam Clayton Powell, Sr., was a hard-living miner in Rendville before he was "saved" at a religious festival at the local First Baptist Church. He later became pastor of the Abyssinian Baptist Church in Harlem, New York, and a prominent civil rights leader.

The coal boom that began in the 1870s was over by the turn of the century, and Rendville entered a period of decline from which it never recovered. By the end of World War II, the coal industry had faltered because of overproduction, and mining work became difficult to find. The town had withered away and consisted of only two stores, a bar, a post office, and just over one hundred homes. This was the place that James Karales encountered while still a freshman student at Ohio University. It was 1953—a year before the Supreme Court ruled in *Brown v. Board of Education* that segregation in public schools was unconstitutional and that separate was not equal—and Karales had found a community that was one of the few integrated towns in the United States and different in almost every conceivable way from Canton, Ohio. Karales was especially drawn to Rendville's black residents, whom he photographed congregating on the street and in storefronts and communing on front porches. He also photographed residents singing, praying, and being moved by the spirit in churches. A tangible current of sympathy runs between the photographer

Peter Sekaer
(American, born
Denmark, 1901–1950)
25th Street, Birmingham,
Alabama, 1938
$7\frac{1}{4} \times 9\frac{1}{4}$ inches
(18.4×23.5 cm)
Vintage gelatin silver print
High Museum of Art,
Atlanta

and his subjects. The dusty streets, weatherbeaten clapboard buildings, and families passing the time in mundane pursuits were compelling subjects for Karales, who generated pictures that are reminiscent of Farmer Security Administration (FSA) photographs of small-town America in the Depression era.

Karales had an eye for the rhythms of everyday life like those recorded in the photographs of the Danish-born photographer Peter Sekaer, an associate of Walker Evans who traveled the country extensively in the 1930s as an employee of various government agencies.[11] Like Karales after him, Sekaer was fascinated by African American life and deeply engaged by the communities he encountered in the South. Both men brought a respectful compassion for people to their photographic practice along with an instinct for capturing intimate, extemporaneous detail.

To accompany his Rendville photographs, Karales sketched layouts for stories and even conceived a publication that might draw closer attention to the plight of the people he portrayed in his pictures.[12] The sociology classes Karales took as part of his undergraduate education seem to have influenced his approach to photography and

his view of its utility for examining human behavior and catalyzing social change. At the same time, he was reading important photography books, such as Margaret Bourke-White's *You Have Seen Their Faces* (1937), which combined her photographs with text by Erskine Caldwell highlighting poverty in rural America.[13] This publication was a critical success for its convincing support of the Rooseveltian belief that America could redeem itself by a return to community and interdependence rather than competitive individualism. For Karales it provided an important model of how photographs and text could be productively combined and an example of how he might incorporate into his photographic practice some sense of a common, shared humanity. He later said, "I believe that photography has, as its fundamental basis, two goals which appear as a paradox: creative expression and scientific analysis. As do all the other fine arts, photography humanizes us, since it so compellingly reveals human qualities. As a photographer, I've tried to capture and communicate some of the important aspects of our environment and hopefully contribute to the scope of photography as a creative medium and a genuinely universal means of communication."[14] Another early project that suggests Karales's interest in using photography as a form of "scientific analysis" was his photo-essay on the Lakin Boys Industrial School in Lakin, West Virginia, a progressive reform school for delinquent young African Americans. Karales gained the confidence of the school's superintendent and was allowed privileged access to document the innovative methods the school used in rehabilitating its students.[15] Karales hoped to continue this work but could not self-fund it, and the photographs were never published; yet their existence signals the seriousness of the photographer's immersive approach and his commitment to a self-assigned form of reporting that tackled social issues from an informed, experiential point of view.

New York

Thinking of photography as a "universal means of communication" was top of mind for Edward Steichen, curator of photography at the Museum of Modern Art in 1955, the year Karales graduated from Ohio University and moved to New York City to pursue a career as a professional photographer. In the spring of 1955 Steichen was deeply immersed in organizing *The Family of Man*, a behemoth traveling exhibition of more than five hundred photographs made by 273 photographers from sixty-eight countries.[16] The most successful photographic exhibition ever mounted, it was seen by more than nine million people in the United States and abroad. In the accompanying catalog, Steichen described the rationale for the project and photography's

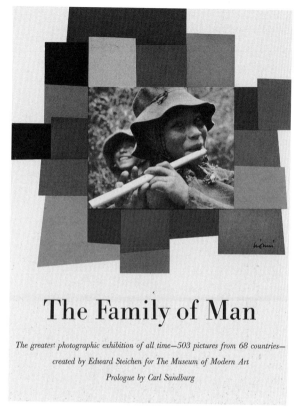

The Family of Man

The greatest photographic exhibition of all time—503 pictures from 68 countries—

created by Edward Steichen for The Museum of Modern Art

Prologue by Carl Sandburg

Dust jacket for the catalog to Edward Steichen's groundbreaking 1955 exhibition.
Private collection.

distinct ability to communicate the human condition: "the art of photography is a dynamic process of giving form to ideas and explaining man to man. It was conceived as a mirror of the universal elements and emotions in the everydayness of life—as a mirror of the essential oneness of mankind throughout the world."[17] This message of universal kinship was articulated through the carefully orchestrated presentation of images, texts, and architectural space. Moreover, as Brett Abbott has remarked, "Steichen, in effect, organized the exhibition as a picture-magazine editor would have organized a photo essay."[18]

Karales wasted little time in introducing himself to Steichen, a propitious encounter resulting in the purchase of two photographs from Karales's project documenting the Greek American community of Canton for the Museum of Modern Art's collection. This acquisition was the beginning of a fertile dialogue between the young photographer and the country's most important institutional curator. Steichen acquired another three prints by Karales in March 1958, this time including at least one photograph from the Rendville project.[19]

Just as important was Steichen's encouragement and his suggestion that Karales approach the Magnum agency for work. The young photographer met with Magnum editor John Morris, who declined to sign Karales with the agency but offered something much more alluring—an introduction to W. Eugene Smith, whose work was prominently featured in *The Family of Man*. Smith's professional life was in upheaval at that moment. He had resigned from *Life* magazine the previous year and, after a brief and unhappy engagement with Magnum, had begun representing himself.[20] Meeting Smith was the fulfillment of a dream for Karales, who, while still at Ohio University, had become familiar with Smith's work, feeling an affinity for Smith's firebrand approach to socially committed photography and his flair for the photo-story. When the two were introduced, Smith was in the nascent stages of a monumental project to celebrate Pittsburgh's bicentennial by documenting the city in all its facets. He had begun this

work at Magnum with the veteran editor Stefan Lorant but disagreed with Lorant on the scope of the assignment and obsessively transformed it into the most ambitious project of his career. Smith exposed an estimated seventeen thousand negatives and took several years to print the final edit.[21]

Karales walked into the maelstrom of Smith's long-form study of Pittsburgh. Direly in need of help, Smith immediately engaged Karales to assist with printing the photographs for the project. In lieu of wages Smith provided room and board at his family home in Croton-on-Hudson, an arrangement that lasted for two and a half years. Karales labored intensively alongside Smith, sometimes accompanying him when he photographed in Pittsburgh, but mostly printing through the night as Smith's spouse, children, and housekeeper slept. Fueled by alcohol and amphetamines, Smith directed his apprentice and together they generated more than eleven thousand proof prints from 5 × 7 inch negatives. It was exhausting work but also heady and rewarding. Already a proficient technician, Karales came away from this experience as a superb printer and master of the darkroom arts.

W. Eugene Smith Photographing in Pittsburgh, 1955–56
5⅞ × 4¼ inches (14.8 × 10.7 cm)
Vintage gelatin silver print
Estate of James Karales

Smith never completed his Pittsburgh opus, but his unquenchable appetite for photography and his zeal to perfect the subtleties of its craft had a transformative effect on Karales. Describing the darkroom technique that he developed under Smith, Karales recalled, "It was the contrast that made the prints difficult. . . . It wasn't so much print quality as the balance of the photograph, so your eye went directly to what he thought the picture was about. . . . It was extremely delicate and complicated, but we got it down pat."[22] Smith convinced Karales that the negative was merely an accumulation of information. It was making the print that provided the real challenge. Karales learned to produce prints that were dark and soulful, laced with inky blackness and peppered with dazzling glints of light. He wholeheartedly embraced the rituals of the darkroom and learned how to convey purposefully what he wished to express photographically.

Images into Print

By the end of World War II, photographs occupied roughly one-third of news space in the average newspaper in the United States. Editors understood the photograph's ability to convey explicit information about a personality or event as well as its capacity to dramatically increase sales. The prevalence of independent news agencies such as United Press International (UPI) and the Associated Press (AP) was significant, prompting a seismic shift in the way that photographs were shared and disseminated. Wirephoto technology was in its heyday during the 1950s and 1960s, and the growing popularity of television helped accelerate the visibility of the social protest and civil rights movements. But despite the growth in numbers of viewers, television had not yet displaced the printed page nationwide as the medium through which most Americans consumed the news. Magazines such as *Time, Newsweek, Look, Life, Jet,* and *Ebony* did brisk business and revolutionized the use of photography by publishing dramatic stories that were built around a clutch of carefully edited images. *Look* magazine was published biweekly (rather than weekly like its primary competition, *Life*), and this schedule allowed its editors to pitch in-depth, richly illustrated stories that spanned as many as six to twelve pages.

Karales joined the staff of *Look* magazine in 1960 after a successful review of his portfolio by the assistant managing editor, Patricia Carbine. The introduction was made by Paul Fusco, a staff photographer who had attended the same program as Karales at Ohio University a couple of years behind him. The two had been good friends ever since. Karales joined a stable of talented journalists and photographers. Besides Fusco, they included Arthur Rothstein, John Vachon, Tony Vaccaro, and Stanley Kubrick (before he became a filmmaker). The environment was highly competitive. The editor dispatched photographers into the field to cover specific stories, and the art director maintained control over the final layout. Central to the process was the contribution of the writer, whose reputation and performance held sway. Fusco described the atmosphere in the workplace as "a friendly war," as photographers jockeyed among each other for space and negotiated with the art director, Allen Hurlburt, for a say in the image sequencing and layout of published stories.[23] *Look* hired Karales as a salaried employee, providing him financial stability for the first time in his life, an essential requirement with a young wife and a growing family.[24] He remained with the magazine for eleven years until it ceased publication in 1971. Almost as important as the steady income was the fact that the magazine was not as predictable in format and content as *Life, Newsweek,* and other competitors.

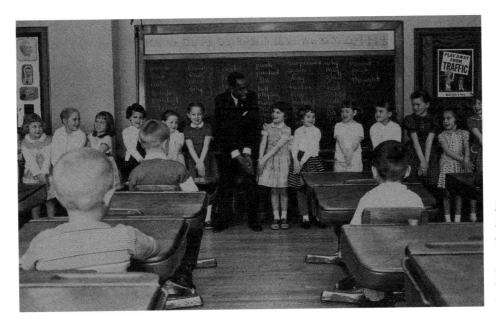

*Richard Adams
Leading a Class,
Clarion, Iowa, 1960*
5 9/16 × 9 1/8 inches
(14.6 × 23.2 cm)
Vintage gelatin silver print
Estate of James Karales

Karales had wide-ranging assignments that took him across the length and breadth of the United States as well as overseas. During his eleven-year stint at *Look*, Karales made photographs of public personalities as varied as baseball player Roger Maris, author James Baldwin, *Vogue* editor Diana Vreeland, tennis player Arthur Ashe, boxer Cassius Clay, architect I. M. Pei, artist Salvador Dali, songwriter Glen Campbell, and civil rights leaders Robert Moses and Dr. Martin Luther King, Jr.

Within weeks of joining *Look*, Karales had two assignments that set the compass for his deep engagement with the major civil rights issues of the day. The first was a set of pictures he made of Richard Adams, a young black social worker and speech therapist, who worked mainly with white public school students in rural Iowa. A pioneer in his field, Adams was the subject of a profile in the April 7, 1960, edition of *Jet* magazine.

A month later Karales photographed Adams in a classroom with students in Clarion, Iowa.[25] The pictures from this assignment demonstrate how adept Karales was at capturing the humanity of his subject, as well as his knack for recording intimate moments that transcended his role as a working journalist. He titled one such photograph *Negro Therapist, Iowa*, printing the image large and mounting it on a board as an exhibition-quality print.

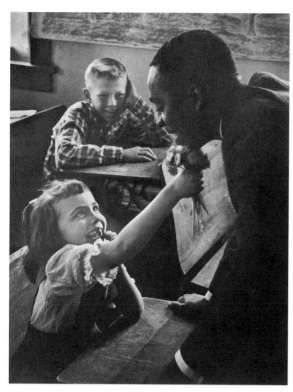

Negro Therapist, Iowa, 1960
8 5/8 × 7 1/4 inches (23.4 × 18 cm)
Vintage gelatin silver print
Estate of James Karales

Karales traveled directly from his Iowa assignment to Atlanta, Georgia, to photograph a story about student-led forms of nonviolent direct action. In the spring of 1960 public schools in New Orleans and Atlanta desegregated, and a vigorous sit-in movement blossomed across the southeastern states. All over the region educated and motivated young students received training from vanguard strategists. They were prepared to express their activism in unfamiliar and untried ways and willing to go to jail for their beliefs. Nashville became a particularly prominent center, with instruction in nonviolent social protest led by a trio of inspirational ministers: C. T. Vivian, James Lawson, and Kelly Miller Smith. Lawson had trained in India and learned the validity of Mohandas Gandhi's philosophy of nonviolence as an instrument of social change.[26] Lawson traveled to campuses across the South, leading workshops for black and white students. Karales photographed the program that young activists affiliated with the Atlanta-based Student Nonviolent Coordinating Committee (SNCC) undertook on the campus of Morehouse College (plates 1–8). They were taught methods of nonviolent civil disobedience, learning how to employ the tactics of passive resistance in the face of extreme provocation and how to absorb verbal and physical abuse without responding in kind.[27] Among the group was Johnny Parham (plate 1, far right), a freshman from New York City who participated in many sit-ins at Woolworth's and Leb's delicatessen lunch counters in Atlanta. Parham sent a description of SNCC's activities to *Look* magazine as background for the story.[28] Karales made more than forty photographs of the training and produced a large number of proof prints for consideration by the editor. Although the article did not run, the large number of surviving prints (some of which are variant croppings from the same negative) indicates that Karales deemed the work important and had much more than a passing interest in the subject.[29]

Karales was able to extend his involvement with civil and human rights in the winter of 1960, when he completed an assignment for *Look* on the subject of segregation in New York City.[30] He was keenly aware of the centrality of the issue to political and cultural life throughout the country, not just in the South.

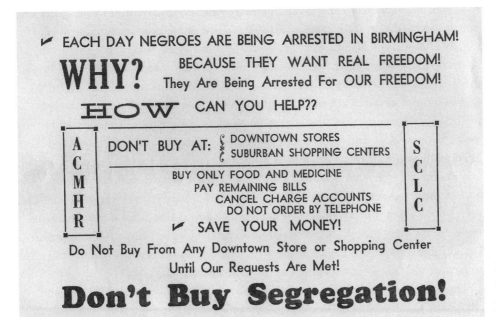

Flyer distributed in Birmingham, Alabama, 1962–63. Private collection.

In Birmingham, Alabama, that state's largest city, Klan violence was endemic, and city leaders refused to comply with federal desegregation orders despite the considerable size of the African American population. Reverend Fred Shuttlesworth, head of the Alabama Christian Movement for Human Rights (ACMHR), led a community of black activists who were determined to transform the nation's most segregated city. Shuttlesworth, whose home had been bombed to ruins in 1956, persuaded Dr. Martin Luther King, Jr., to make Birmingham the focus of his next campaign, with the goal of overturning the city's reputation as the nation's "chief symbol of racial intolerance."[31]

Picturing an Icon

In the fall of 1962, *Look* sent Karales to Birmingham, Alabama, to cover the first fully integrated convention of Dr. King's civil rights organization, the Southern Christian Leadership Conference (SCLC). The focus of the convention was King's collaboration with Reverend Shuttlesworth and other leaders in Birmingham to increase voter registration and strategize for a widespread shopping boycott of downtown stores and other acts of nonviolent civil disobedience.[32]

At the end of the convention, during the closing announcements, a young white male approached the stage from the audience and landed a punch on King's left cheek.

King staggered backward and his assailant, Roy James, followed up with a flurry of punches. King dropped his arms by his side (an instinctive nonviolent gesture) and quietly implored the man to stop. In the scuffle that ensued, several preachers and King confidants—among them Wyatt T. Walker, Andrew Young, and Bernard Lee—ushered King and his assailant off the stage and into an adjacent hallway. Karales was well positioned to track the action moment by moment from a location near the front of the auditorium, and he was on hand to capture the exchange that followed between King and his assailant (plate 16). James explained to King—and the attendant law enforcement—that he was a white supremacist and a "soldier" on a mission for the American Nazi Party. King defused the danger, calmly explaining to an irate Birmingham police official, "This system that we live under creates people such as this youth. I'm not interested in pressing charges. I'm interested in changing the kind of system that produces this kind of man."[33] While King refused to press charges, the Birmingham Police Department had the last word, persuading James to plead guilty and dispatching him to jail to serve thirty days.

Sensing a good story in the making, Karales followed the bruised and shaken King back to the Gaston Motel, where he usually stayed during his Birmingham campaigns, and photographed him as he addressed a crowd of onlookers from the balcony (see plates 17–19). From there Karales trailed King back to Atlanta.

King's demanding schedule kept him away from home almost half the week and much more at times of crisis. Amid the unrelenting pressure and a dizzying slate of commitments, King thought of himself as family man and treasured the time he had with his wife and children—Yolanda, Martin Luther III, Dexter, and later Bernice. During this particular family weekend, Karales secured rare permission to photograph King with his family at home (see plates 20–25). The photographs were published on a six-page spread in the February 12, 1963, issue of *Look*.[34]

Included was a picture of King at the dinner table with his daughter Yolanda (seven years old at the time), helping her understand her first painful brush with segregation by explaining that she could not patronize Fun Town, a popular amusement park in Atlanta, because of the color of her skin. King's more playful side is visible in photographs made of the family gathered in the yard as King played with his first son, five-year-old Martin Luther III (plates 20 and 21). Coretta Scott King is visibly pregnant in these pictures, as the Kings were expecting their fourth child, Bernice, who was born on March 28, 1963.

King was prepared to accept Karales's intrusion on his personal life in part because he understood the evidentiary power of photographs and recognized that such pictures exemplified the concept of family solidarity and conveyed a sense of him as

Facing and following page: Karales's photo-essay on the King family. *Look* 27 (February 12, 1963): 92–96.

A VISIT WITH Martin Luther King

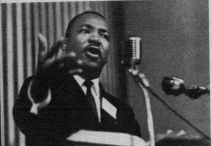

In a style that combines intellect with intensity, King addresses a Birmingham, Ala., congregation.

A Negro leader talks about the struggle ahead

BY ERNEST DUNBAR
LOOK SENIOR EDITOR

At 34, the Rev. Dr. Martin Luther King, Jr., has become an American institution. Since he led a Negro boycott of Montgomery, Ala., segregated buses in 1955-56, the young Baptist minister's name has become known in the remotest corners of the world. When the head of newly independent Algeria came to America last year to see President John F. Kennedy, he also requested a special briefing on U.S. race relations by Martin Luther King. Kennedy himself has occasionally invited the counsel of King, and candidate Kennedy's call to the wife of the then-imprisoned minister during the 1960 campaign is widely credited with swinging enough Negroes behind Kennedy to give him his thin margin of victory.

Palavering with Presidents has not diverted King's attention from his role as a battler for equality. But today, the King influence ranges far beyond the borders of his native Southland. During one recent week, he spoke at a fund-raising rally in White Plains, N. Y., on Tuesday. On Wednesday evening, he addressed similar rallies in two other New York towns. On Thursday, he met in Manhattan with fellow board members of the *continued*

PHOTOGRAPHED BY JAMES H. KARALES

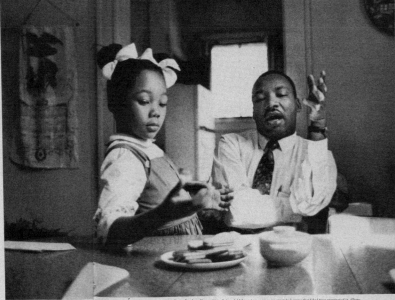

"I told my child about the color bar," says King, "after she'd begged to be taken to Fun Town, an Atlanta amusement park that she'd seen advertised on television. I knew they had not asked Negroes. But I told Yoki that, even though she could not go, she was as good as anybody else. I think she understood. Sometimes later, she became very upset by hearing that I had been imprisoned in Albany, Ga. It isn't easy to explain such things to a seven-year-old, but my wife Coretta told her that I was in jail so that all people could go where they wished without worrying about their color. 'Good,' Yoki said. 'Tell him to stay in jail until I can go to Fun Town.'"

92

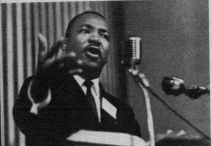

The Kings enjoy a backyard romp at their Atlanta home. The couple are expecting a fourth child.

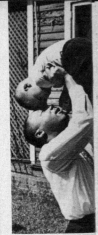

King playfully hoists five-year old Martin III. Frequent absences from his family are among the most serious of the sacrifices demanded of him in his work.

Coretta and Martin Luther King join hands to sing hymn "We Shall Overcome" at convention of integration groups. Like King, she is a native of the South.

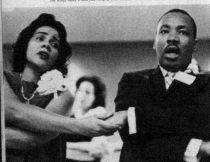

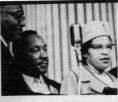

MARTIN LUTHER KING continued

King, center, listens as Mrs. Rosa Parks accepts an award. Her arrest for refusing to give up her seat to a white male passenger triggered the King-led 1955-56 Montgomery, Ala., bus boycott.

In Birmingham, Ala., King was taken to police station following his refusal to press charges against a white attacker. Below, his admirers listen intently as King addresses them after his return.

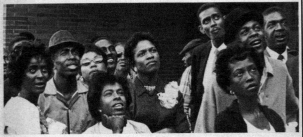

"Give me some shoes to wear down here!"

Gandhi Society, an organization that provides legal aid to Negro integration leaders; then consulted with publishers of a forthcoming book of King sermons, and flew to the West Coast to give lectures to the students at Los Angeles State and San Jose State colleges. On Sunday, he went to Houston, Texas, for a fund-raising dinner. On Monday, he flew to Washington, D. C., to join other Negro leaders for a White House audience with President Kennedy on American policies in Africa. Afterwards, Kennedy and King met alone to discuss the continued bombing of Negro churches in Alabama. At the day's end, King returned to the Atlanta, Ga., headquarters of the Southern Christian Leadership Conference, of which he is president, to help organize an SCLC voter-registration drive in the South. Somewhere, during these days, he managed to write his biweekly column for a Negro newspaper and compose a sermon for his next church service.

The wide-ranging scope of these activities typifies the kind of life King lives today. He has become a symbol of the struggle against bigotry, not only to Southern Negroes, but to those in the North as well. At the same time, his nonviolent methods have won him many white supporters, particularly among college youth, and he is much in demand as a lecturer. Such adulation might make some men pompous, but Martin Luther King remains a warm, friendly, human being. Basically, this is so because it is King's nature. But even if it were not, there are plenty of daily reminders that, despite some successes, his goals are far from being accomplished.

He is the kind of American hero who may find himself lunching with a Northern governor one day and behind the bars of a Southern jail the next. He has been imprisoned twelve times, spent more than 40 days in jail (most recently in Albany, Ga.); his home has been bombed, his family threatened, and he himself roughed up by Southern policemen. He suffers no illusions about the dangers that exist. But while he eschews the martyr role, he is determined to continue his work. "Every man should have something he'd die for," says Dr.

King. "A man who won't die for *something* is not fit to live."

King's fervor may stem partly from his rearing in a family in which religion has always played a dominant role. His great-grandfather was a minister. His maternal grandfather was, for 37 years, the pastor of Atlanta's Ebenezer Baptist Church, where King is now co-pastor with his father, the Rev. M. L. King, Sr. The latter has headed the church for 30 years. A brother, A. D., and an uncle are also ministers. In the pulpit, King summons up masterful oratory that blends Hegel with hallelujahs. His normally gentle tones give way to a rolling, booming baritone that evokes cries of "That's right!" and "Yes, Lord!" The cardboard fans bearing morticians' advertisements swish back and forth with increasing rhythm as King works up to a climax: "It's all right to talk about silver slippers Up There, but give me some shoes to wear down here! It's all right to talk about the mansions Up Yonder, but I want to see some new homes right here! Communism may be in the world because Christianity hasn't been Christian enough, and democracy hasn't been democratic enough." College professors and ill-schooled domestics, his audience is with him, and their cries of assent swell like an orchestra in full voice.

Martin King's missionary zeal permeates the Atlanta headquarters of the Southern Christian Leadership Conference. SCLC is an unbrellalike group that seeks to coordinate and assist local organizations working for the implementation of democracy in America. It has grown from a modest of five people with a budget of $65,000 in 1960 to a present staff of 40 and an annual budget of $475,000. Its activities range from sit-ins at segregated public facilities and voter-registration campaigns to a "citizenship-education" program that sends teams around the South to provide basic instruction to illiterate Negro adults. Though King provides the motive force behind SCLC, much of the administrative burden is carried by another energetic young minister, the Rev. Wyatt Tee Walker, a close King associate.

Periodically, King embarks on a "people-to-people" tour of such areas as backwoods Alabama, the Mississippi Delta or the "wool-hat" rural regions of Georgia, to visit and talk to the Negroes of these racially critical sections. In these areas, where the name Martin Luther King is almost an epithet to whites, King refuses the services of bodyguards, and on a recent visit to Selma, Ala., he came uncomfortably close to being attacked by an angry crowd. To the casual observer, he appears to be almost unconscious of the dangers to which he is frequently exposed. At a convention of the SCLC in Birmingham, Ala., last fall, a visibly disturbed white youth leaped onto the speaker's platform before a stunned audience and began pummeling him. King made no move to defend himself and refused to bring charges against *continued*

94

95

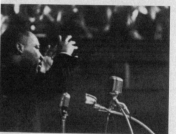

an American everyman. Photographs such as Karales's could help King's cause just as effectively as more charged, action-packed images of protest and confrontation, which conveyed certain truths about the brutality and injustice of life in a segregated society. King had good reason to want to shape how his image was presented in the press. In addition to the tumult of the civil rights movement, war was beginning to escalate in Vietnam, and King later came under fire for speaking out strongly against it. Following John F. Kennedy's assassination in November 1963, President Lyndon B. Johnson practiced a new style of leadership, employing fresh strategies on the home front and in foreign policy.

Vietnam

For journalists the conflict in Vietnam was a major story. They debated how best to report on it, because Vietnam held so much more complexity beyond its locus as a battleground for the forces of communism and capitalism. The question was, as Brett Abbott has explained, "Whether journalism should present news in as neutral and objective terms as possible or whether it should seek to more actively interpret and comment on sitations it depicted."[35] No earlier war had been photographed as extensively as Vietnam, and access to the battlefields was relatively easy. Karales volunteered for the assignments and covered the war on two separate trips, both times with Sam Castan, senior editor at *Look*. Their first visit, in November 1963, generated two stories: "What Johnson Faces in South Vietnam" and "Vietnam's Two Wars," published in the January 28, 1964, issue of *Look*. Both articles were liberally illustrated with photographs by Karales, the most indelible being a picture of a military medic holding the body of a slain Vietnamese child.

Sam Castan's description of the scene is no less powerful: "The child is dead. She died at dawn last November 6 of a bullet, fired by one of her own countrymen, that

ripped into her back and left a fist-sized hole in her chest. Moments later, her father was blown apart by a hand grenade while manning his village's sole machine gun against a Vietcong attack."[36]

Castan and Karales returned for a second, seven-week stint in Vietnam during the winter of 1965, a trip that generated two additional stories, "Vietnam: Washington's Biggest Problem" and "Recollections from a Notebook in Vietnam," both published on April 6, 1965.[37] Karales and Castan dressed in military fatigues so as not to stand out and possibly draw fire, but they were regularly drawn into combat situations on the frontline. Their experiences generated a slew of dramatic photographs and reporting. A letter from a U.S. Army infantry major who worked alongside the two correspondents on their 1965 trip attests to the dangers they encountered in the field: "The purpose of this letter is to relate to you the gallant bravery of Mr. Castan and Mr. Karales when under mortar, automatic weapons and small arms fire delivered from close range. Based on demonstrated courage, both gentlemen qualify as excellent soldiers in any army. They exposed themselves to hostile fire repeatedly in an effort to record the action accurately and I was personally proud to observe LOOK magazine in action."[38] As it did for so many servicemen and women, being in Vietnam exposed Karales to extremes of brutality and trauma that had a significant impact on his emotional life. It was a harrowing experience, and his photographs show it.

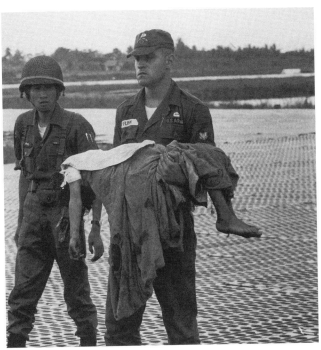

GI Medic Carrying a War Victim, Vietnam, 1963
12½ × 11¾ inches (31.8 × 29.8 cm)
Vintage gelatin silver print
Howard Greenberg Gallery, New York / Estate of James Karales

The March for Voting Rights

No more than a few weeks after his return from Vietnam, Karales was on the front lines once again. This time he found himself among the scores of print journalists, television reporters, and photographers from around the country who traveled to Alabama to participate in and record the Selma to Montgomery March for Voting

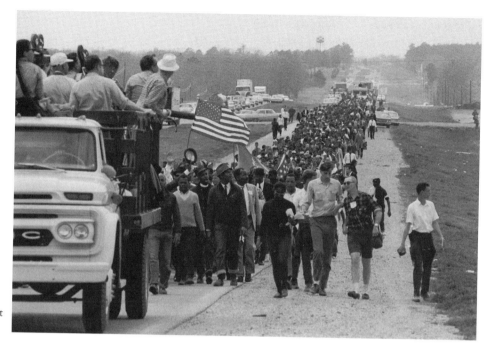

*Press Truck in
Advance of Marchers,
Selma to Montgomery
March, 1965*
7 × 10 ⁵/₁₆ in.
(17.8 × 26.3 cm)
Vintage gelatin silver print
Estate of James Karales

Rights in the spring of 1965. Almost every important news organization had report-
ers, photographers, and camera crews on the ground in Alabama, with personnel
who were experienced in press coverage.[39] The fifty-four miles along Highway 80
from Selma to Montgomery took marchers five days to complete. It was the largest
civil rights demonstration the state had ever seen. Newcomers who had never before
participated in the movement walked side by side with veterans who had been cam-
paigning for the right to vote for more than a decade. By the final day of the march—
the entry into the state capital, Montgomery, on March 25, 1965—the number of
marchers had swelled to almost thirty thousand people.

On the march from beginning to end, Karales made dozens of photographs along
the route.[40] He documented the daily proceedings thoroughly, switching off from his
position on the press truck that preceded the column of marchers to moving freely
among them to capture candid pictures of democracy in action.

Having tracked Dr. King in earlier years, Karales was well attuned to the historic
significance of the occasion and understood his obligation to record the totality of
the event while simultaneously documenting a cross section of the participants. Kara-
les worked closely on the assignment with Christopher Wren, a gifted young *Look*
writer who was particularly interested in the role that organized religion—priests,

ministers, nuns, and rabbis—played in supporting Dr. King's effort and protesting and publicizing African American disenfranchisement under the discriminatory southern Jim Crow laws. The focus of Karales and Wren's story was wholly appropriate, because King had sent telegrams from Atlanta to prominent clergymen and religious leaders across the country to mobilize their support in advance of the march.[41]

The remoteness of some parts of Highway 80 in rural Alabama presented challenges to even the most experienced reporters. Those working for daily newspapers had the added pressure of filing their stories on the spot, which could be accomplished by tapping directly into the phone lines that were available along the route. Wren's research and Karales's photographs were later shaped into two related articles, which were published alongside each other in the May 18, 1965, issue of *Look:* "Our Churches' Sin against the Negro" and "Turning Point for the Church."[42]

Karales did some of his best work when he moved among the marchers, capturing the remarkable endurance and stoic commitment of participants such as Jim Letherer from Saginaw, Michigan, who covered the entire fifty-four miles on crutches (plates 58, 73, and 87), and Sister Mary Leoline from Kansas City, the only nun to walk the whole way (plates 45, 48, 72, 74, 83, and 84). A close study of the surviving negatives and contact prints reveals that Karales was persistently drawn to the buoyant activism of the younger participants, their faces full of emotion and expectation, striving for a better future. As they settled into camp each evening, Karales captured their exhaustion as well as the euphoria brought on by hours spent marching in extreme weather conditions, from burning sun to driving rain. Unlike some reporters and photographers, Karales camped with the marchers in makeshift tents (plate 69) pitched alongside Highway 80 in wet and muddy conditions, rather than seek the comforts of a motel room back in Selma or ahead in Montgomery.[43] Volunteers shuttled food, water, medical supplies, and latrines (plate 68) from the march headquarters in Selma. Staying

James "Spider" Martin (American, 1939–2003)
Reporter Al Fox Calling in a Story, Selma to Montgomery March, 1965
10 × 8 in. (25.4 × 20.3 cm)
Vintage gelatin silver print
High Museum of Art, Atlanta

close to events allowed Karales to experience firsthand the unity of the marchers and to better understand their cause. On the third day of the march, Karales made the photograph that he thought best conveyed the power and purpose of the marchers as they advanced in a snakelike procession across the barren landscape of Highway 80 in Lowndes County (plate 63). A study of the corresponding contact sheet shows that he exposed as many as a dozen frames before he got the picture that became the iconic image not only of this march but the entire civil rights movement.

Throughout the five-day march, Dr. King was accompanied by a steady stream of movement notables, including Rosa Parks; Roy Wilkins of the NAACP; John Lewis, James Forman and James Bevel of SNCC; Whitney Young of the National Urban League; and Nobel laureate Ralph Bunche. Among the celebrities were writer James Baldwin, singers Joan Baez and Tony Bennett, actor Harry Belafonte, and comedian Dick Gregory. Karales documented them all in action, swept along by the boundless optimism of impending social change. On the entry into Montgomery, Karales photographed Loveless School, the city's first junior and senior high school for African American students. His picture of youths lining the sidewalk (plate 82) and peering down through open windows to get a better view of the marchers (plate 81) offered hope and the possibility that real and meaningful change was on its way. The breadth of Karales's achievement is barely perceptible in the story that was published in the pages of *Look*. It requires a detailed study of the surviving negatives and contact sheets to gauge the extent of his accomplishment. For Karales being on the March for Voting Rights was a high point in his journalistic career because he recognized that he was fortunate to bear witness to a transformative moment in American history. In a rousing concluding speech on the steps of the state capitol building in Montgomery, King declared that "segregation is on its deathbed in Alabama."[44] Fewer than five months later, on August 6, 1965, King, Rosa Parks, and other civil rights luminaries stood beside President Lyndon Johnson when he signed the Voting Rights Act, ensuring that African Americans could no longer be denied a political voice. Johnson described the right to vote as "the most powerful instrument ever devised by man for breaking down injustice" and the Voting Rights Act as "one of the most monumental laws in the entire history of American freedom."[45]

Photography readily obeys the rules of nonfiction and its job is to make the world visible, which it does more democratically than all other visual arts. James Karales knew this and dedicated himself to making photographs that tell a story and say something meaningful about the human condition. His work is part of a long-established tradition of social realism, which maintains a close connection between

Facing: Selma to Montgomery March—Contact Sheet, 1965
10 × 8 in. (25.4 × 20.3 cm)
Vintage gelatin silver print
Duke University, Rare Book, Manuscript and Special Collections Library

the camera's unguarded eye and the democratic imperative to look directly at modern life, particularly the unsavory and the unseen, in a specific and unidealized way. As a committed and informed journalist, Karales understood what he was looking at and sought to maintain absolute fidelity to the scene that appeared before the camera. He realized what he wanted to say about his subject, and he photographed with insight and sensitivity, working around the civil rights story intuitively, exploring different vantage points and looking for its emotional truth. He hoped to reveal something of the lives and histories of the people in his photographs, to shine a light on them, and to let the world know that what they stood for and what they did mattered.

Notes

1. Steven Kasher, *The Civil Rights Movement* (New York: Abbeville Press, 1996), 17.

2. Karales's photograph was first reproduced in a newspaper when it appeared in the *New York Times*, Sunday, September 5, 1965, X19. It was also the lead image and was discussed in some detail in the review for an exhibition at the Howard Greenberg Gallery, New York; see Vicki Goldberg, "Beyond a Famous Shot, the Art of a Lifetime," *New York Times*, July 23, 1999, E35; a notice for the review appeared on E33 under the title "Fifty-One Works by James Karales, Famous for a Single Image." The photograph has been liberally reproduced in the decades since and was the cover image for the companion publication to a PBS television series, Juan Williams's *Eyes on the Prize* (New York: Viking Press, 1987). It was also used on the cover for *Parting the Waters* (New York: Simon & Schuster, 1988), volume 1 of Taylor Branch's trilogy of books chronicling the civil rights era. In 2007 the NEH selected the photograph (along with Lange's *Migrant Mother*) as one of forty images in the Picturing America program, which illustrates United States history through its art. For more information see http://picturingamerica.neh.gov (accessed May 8, 2012).

3. This information comes from an October 20, 1955, letter written to James Karales by J. P. Manos, a family friend from Canton, Ohio, who provided a summary of the Karales family history; Estate of James Karales.

4. Biographical information on Karales is limited and is mostly found in the artist's estate. Howard Greenberg and Bob Shamis, eds., *James Karales* (New York: Howard Greenberg Gallery / Göttingen: Steidl, 2013), does not include a chronology or detailed biographical information about the photographer.

5. *The Tivo* (1947), yearbook of the Timken Vocational High School, Timken, Ohio; Estate of James Karales.

6. Undergraduate essays by Karales on the art of Constable, Rubens, Modigliani, and Vincent Van Gogh exist in the archives of the Estate of James Karales.

7. Edward Steichen, *Memorable LIFE Photographs*, exhibition catalog (New York: Museum of Modern Art, 1951), n.pag. Steichen's text appears opposite *Sandhog's Tunnel under the East River, New York*, a series of photographs by Carl Mydans.

8. This language appears in the draft of an application for a Guggenheim Fellowship, which Karales prepared (but never submitted) in the fall of 1955; Estate of James Karales.

9. While a checklist for this exhibition does not exist, thirty-six prints from the Greek-American essay (mounted on boards measuring 13 ¾ × 10 ¾ inches) are preserved in the Estate of James Karales, together with dozens of contact sheets and proof prints. Twelve pictures from the series were published as an essay titled "The Greeks of Canton" in *Jubilee* (January 1957): 28–35.

10. This photo-essay on the Naval Air Reservists of Squadron VS 653 was published as "Ohio Sub Hunters" in the *Cleveland Plain Dealer Pictorial Magazine*, August 21, 1955, 34–35.

11. See John T. Hill, *Signs of Life: Photographs by Peter Sekaer* (Atlanta: High Museum of Art / Göttingen: Steidl, 2010).

12. These Rendville pages (together with dozens of proof prints and "finished" mounted prints) are preserved in the Estate of James Karales.

13. Karales owned a copy of Margaret Bourke-White and Erskine Caldwell's *You Have Seen Their Faces* (New York: Duell, Sloan & Pearce, 1937) as well as a second publication by them, *Say, Is This the U.S.A.?* (New York: Duell, Sloan & Pearce, 1941). By no means an avid reader, Karales did acquire copies of notable mid-century photography books published by the Museum of Modern Art, New York, including Nancy Newhall, *The Photographs of Edward Weston* (New York: Museum of Modern Art, 1946); Lincoln Kirstein and Beaumont Newhall, *The Photographs of Henri Cartier-Bresson* (New York: Museum of Modern Art, 1947); and Beaumont Newhall, *The History of Photography from 1839 to the Present Day* (New York: Museum of Modern Art, 1949). These volumes are preserved in the Estate of James Karales.

14. Quoted by Vicki Goldberg, "James Karales: The Light and Dark of Photojournalism," in Greenberg and Shamis, eds., *James Karales,* 9–15.

15. Sixteen rolls of 35mm negatives and corresponding contact sheets on the Lakin Boys Industrial School are preserved in file E-13, Estate of James Karales.

16. See John Szarkowski, "The Family of Man," *The Museum of Modern Art at Mid-Century: At Home and Abroad* (New York: Museum of Modern Art, 1994), 1227, and Eric. J. Sandeen, *Picturing an Exhibition: The Family of Man and 1950s America* (Albuquerque: University of New Mexico Press, 1995), 39–75.

17. Edward Steichen, introduction to *The Family of Man,* exhibition catalog (New York: Museum of Modern Art, 1955), n.pag.

18. Brett Abbott, *Engaged Observers: Documentary Photography since the Sixties* (Los Angeles: J. Paul Getty Museum, 2010), 15.

19. The Museum of Modern Art (MoMA) has nine prints by James Karales. Two were acquired by purchase in 1955, three in 1958, and four at an unknown date in the 1960s. However, the prints were not accepted into MoMA's permanent collection but were added to the "Departmental Collection" for ease of storage and cataloging. The two prints acquired in 1955 are mounted on masonite with the remnants of hanging hardware, indicating that they were exhibited at MoMA at some point during the period. I am indebted to Dan Leers at MoMA for sharing this information with me in e-mail correspondence, May 31, 2011.

20. See Glenn Willumson, *W. Eugene Smith and the Photographic Essay* (Cambridge: Cambridge University Press, 1992).

21. See Sam Stephenson, *Dream Street: W. Eugene Smith's Pittsburgh Project* (Durham: Duke Center for Documentary Studies / New York: Norton, 2001); see also Abbott, *Engaged Observers,* 99.

22. Quoted by Sam Stephenson, "A Permanent Imprint," in Greenberg and Shamis, eds., *James Karales,* 172.

23. Paul Fusco, conversation with the author, July 2, 2011.

24. Karales married his childhood sweetheart, Eleanor Francis, in 1957, and they had two sons, Joseph and James, Jr. They maintained a home in Croton-on-Hudson, New York. The couple separated in 1973.

25. Karales made forty-two negatives on the assignment. It was logged on May 2, 1960, as job # 60-8798 in the *Look* Archives at the Library of Congress, Washington, D.C. The *Look* Archives are accessible online at http://www.loc.gov/rr/print/guide/port-2.html (accessed May 14, 2012).

26. David Halberstam, *The Children* (New York: Random House, 1998), 47–49 and Williams, *Eyes on the Prize,* 129.

27. The story is identified as job # 60-8809 in the *Look* Archives at the Library of Congress, Washington, D.C.

28. I am grateful to Johnny Parham for this information. I met Mr. Parham at a conference marking the fiftieth anniversary of the founding of SNCC at Shaw University in Raleigh, North Carolina, April 14–17, 2010. While Parham vividly remembered his training in these workshops on methods of nonviolent direct action, he did not recall a photographer being present at them.

29. These prints may be viewed at the Howard Greenberg Gallery, New York, and the Rebekah Jacob Gallery, Charleston, the primary representatives of the Estate of James Karales.

30. Filed as job # 60-9089 in the *Look* Archives at the Library of Congress, Washington, D.C.

31. King, quoted in Aldon D. Morris, *The Origins of the Civil Rights Movement* (New York: Free Press, 1984), 251.

32. See Branch, *Parting the Waters,* 652–56.

33. See *Look* 27 (February 12, 1963): 96.

34. Filed on October 21, 1962, as job # 1028-62 in the *Look* Archives at the Library of Congress, Washington, D.C.

35. Abbott, *Engaged Observers,* 19.

36. *Look* 28 (January 28, 1964): 20. All the photographs reproduced in this article were in black and white. Karales's photographs were the subject of several readers' letters to *Look* 28 (March 10, 1964), 4. One written by Rosemary Davis of Annandale, Virginia, stated: "The picture of the American medic carrying the slain Vietnamese girl. . . . aroused more emotion in me than any great work of art could."

37. *Look* 29 (April 6, 1965): 70–75. All the photographs in "Vietnam: Washington's Biggest Problem" were reproduced in color, a first for Karales. Black-and-white photographs of Castan and Karales in the field accompanied "Recollections from a Notebook in Vietnam," 76–79.

38. See *Look* 29 (April 20, 1965): 16. Castan and Karales collaborated on stories beyond their two stints in Vietnam. For example they worked together on a feature called "Victims of Welfare," about a poor inner-city neighborhood at West 104th Street in New York; see *Look* 27 (March 26, 1963): 68–72.

39. The Selma to Montgomery March was extensively covered in the press. See Kasher, *The Civil Rights Movement,* 162–91. The most comprehensive magazine coverage of the march appeared in *Ebony* 20 (May 1965): 46–86, where Simeon Booker's story, "50,000 March on Montgomery," was accompanied by more than ninety-five photographs by Moneta Sleet, Jr., and Maurice Sorrell, among others.

40. Karales's 35mm negatives and contact prints of the Selma to Montgomery March were among a group of six Karales "essays" that his estate presented to Duke University in 2004; they were added to the Archive of Documentary Arts, in the Rare Book, Manuscript, and Special Collections Library. In addition to the negatives and contact prints for the six essays—on Rendville, logging, Dr. Martin Luther King, Vietnam, the Selma to Montgomery March, and the Lower East Side of New York—Duke received thirty-six vintage prints, six from each series. Duke acquired additional materials for the archive in 2006 and 2007. An online inventory of the James Karales Archive at Duke is available at http://library.duke.edu/rubenstein/findingaids/karalesjames/inv (accessed May 15, 2012). I am grateful to Richard Armacost and Karen Glynn for providing access to these materials during the research for this publication. Vintage prints by Karales are also available at the Howard Greenberg Gallery, New York, and the Rebekah Jacob Gallery, Charleston, South Carolina.

41. For detailed commentary on the role of the clergy and religious leaders in the March for Voting Rights see Branch, *At Canaan's Edge* (New York: Simon & Schuster, 2006), 124–54.

42. Filed as job # 65-2309 in the *Look* Archives at the Library of Congress, Washington, D.C. When *Look* magazine ceased publication (final issue, October 19, 1971), editor William B. Arthur wrote to Karales: "I, for one, will never forget Selma to Montgomery, or Vietnam with Sam Castan. There were so many great ones. But, then, you are a great photographer, and a great person" (October 22, 1971, Estate of James Karales).

43. Bob Adelman, who was covering the Selma to Montgomery March for *Newsweek,* described how exhausting it was to walk backward day after day while trying to secure pictures of the marchers. He carried at least four different cameras (each fitted with different lenses), and at the end of each day he had to unload and label all the film before dispatching it to New York from the Montgomery airport. Adelman preferred the comfort of a hotel to organize his materials and rest, so as to have enough energy to do it all over again the following day (Adelman in conversation with the author, August 21, 2011). Matt Herron, a former SNCC photographer who covered the march as a freelancer, remained on the front lines like Karales and slept in the tents with the marchers (Matt Herron, conversation with the author, August 23, 2011).

44. Quoted in Branch, *At Canaan's Edge, 165.*

45. Williams, *Eyes on the Prize, 285.*

Plates

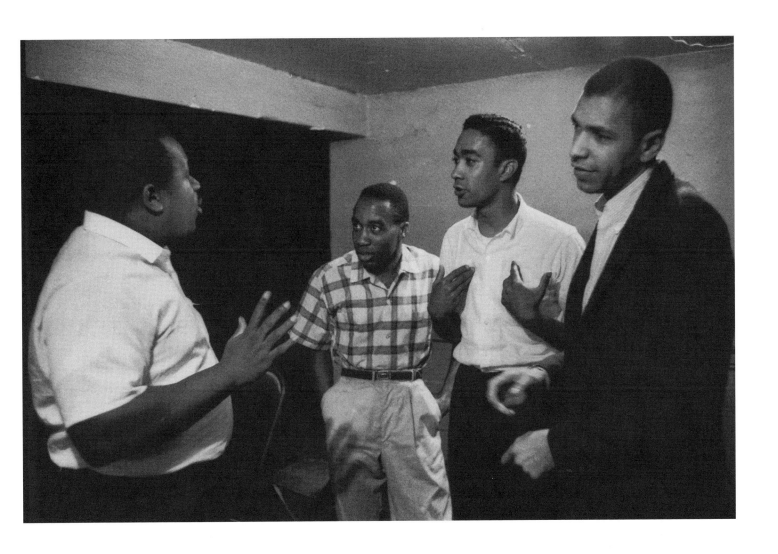

1. *Passive Resistance Training, Student Nonviolent*
Coordinating Committee (SNCC), Atlanta, 1960
9⅛ × 13¾ inches (23.2 × 34.9 cm)
Vintage gelatin silver print
Estate of James Karales

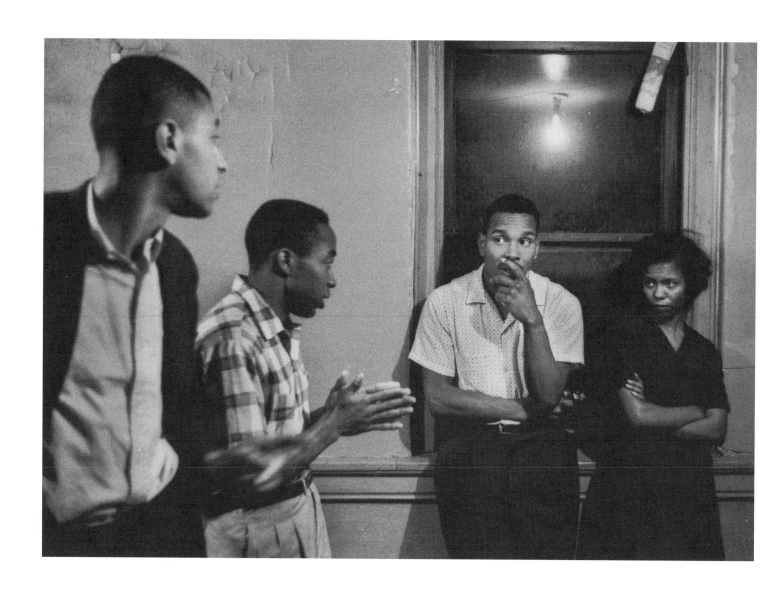

2. *Passive Resistance Training, Student Nonviolent*
Coordinating Committee (SNCC), Atlanta, 1960
9¾ × 13¾ inches (24.5 × 34.7 cm)
Vintage gelatin silver print
Estate of James Karales

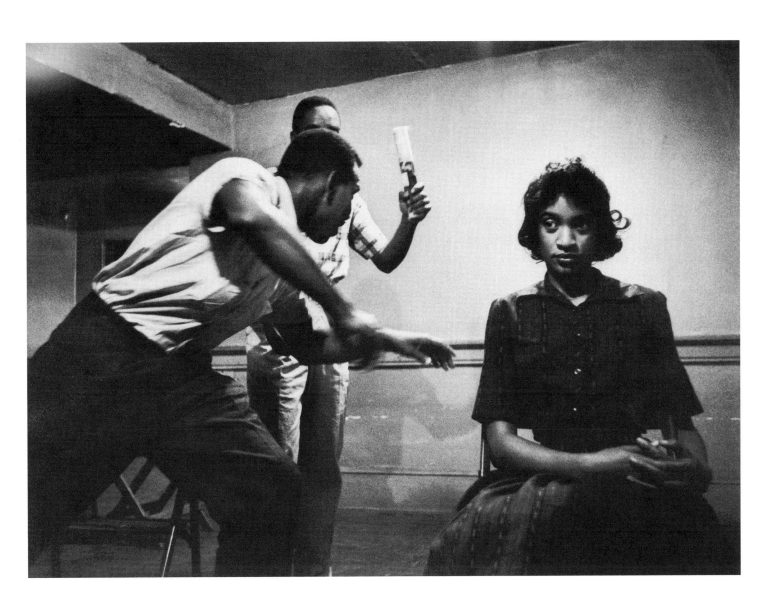

3. *Passive Resistance Training, Student Nonviolent
Coordinating Committee (SNCC), Atlanta, 1960*
10 × 13⅝ inches (25.3 × 34.8 cm)
Vintage gelatin silver print
Estate of James Karales

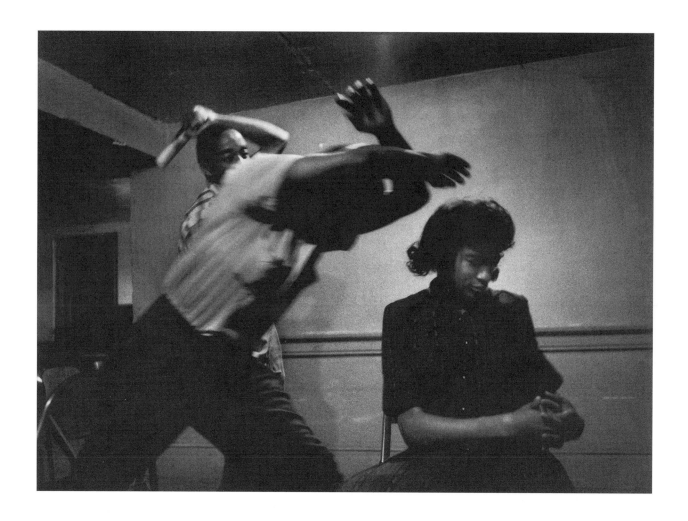

4. *Passive Resistance Training, Student Nonviolent*
Coordinating Committee (SNCC), Atlanta, 1960
10 × 13⅝ inches (25.3 × 34.7 cm)
Vintage gelatin silver print
High Museum of Art, Atlanta

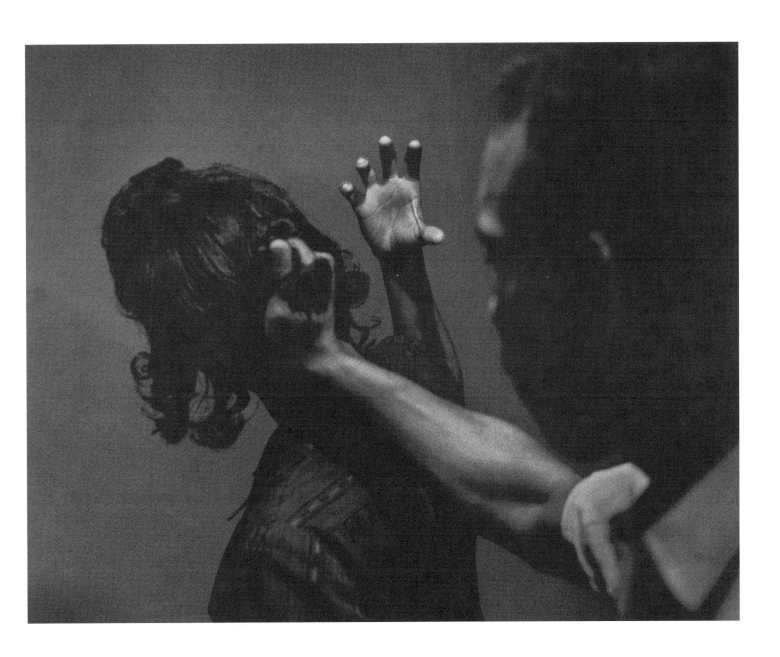

5. *Passive Resistance Training, Student Nonviolent*
Coordinating Committee (SNCC), Atlanta, 1960
10 3/4 × 13 1/2 inches (27.3 × 34.3 cm)
Vintage gelatin silver print
Howard Greenberg Gallery, New York

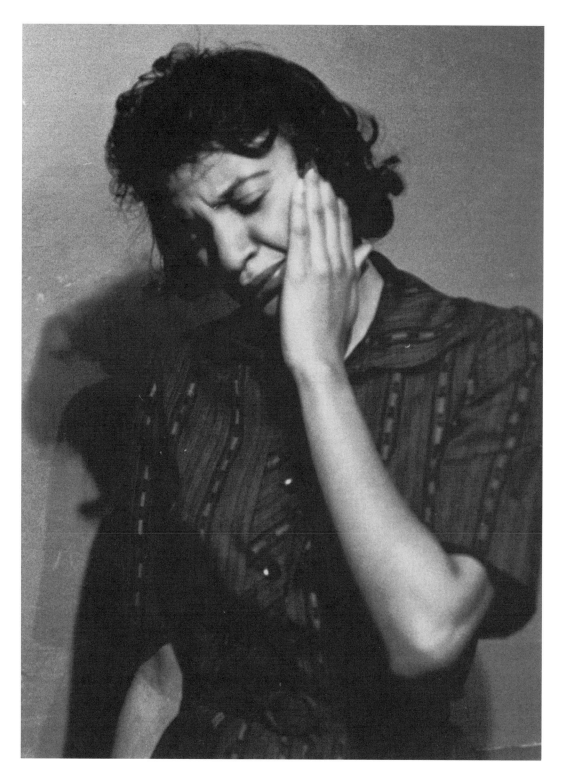

6. *Passive Resistance Training, Student Nonviolent
Coordinating Committee (SNCC), Atlanta, 1960*
6 ¹/₈ × 4 ¹/₂ inches (15.6 × 11.4 cm)
Vintage gelatin silver print
Howard Greenberg Gallery, New York

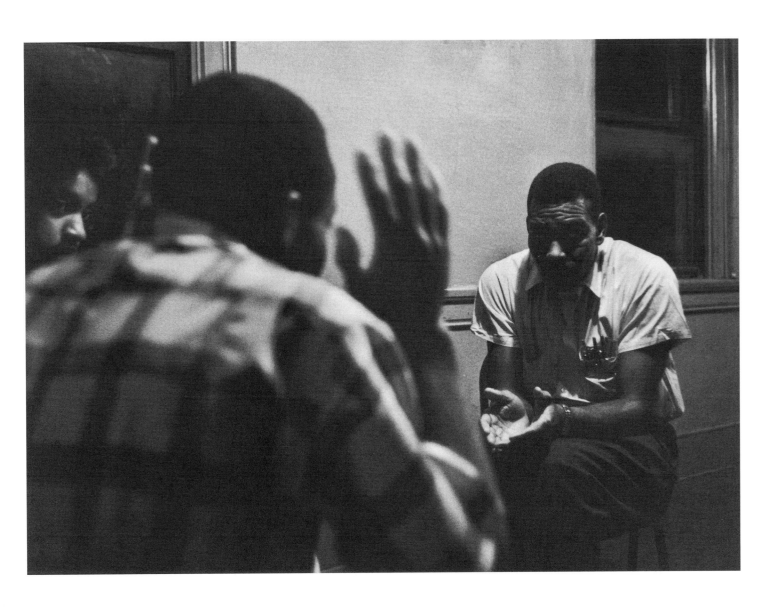

7. *Passive Resistance Training, Student Nonviolent*
Coordinating Committee (SNCC), Atlanta, 1960
10 × 13¾ inches (25.3 × 34.7 cm)
Vintage gelatin silver print
Estate of James Karales

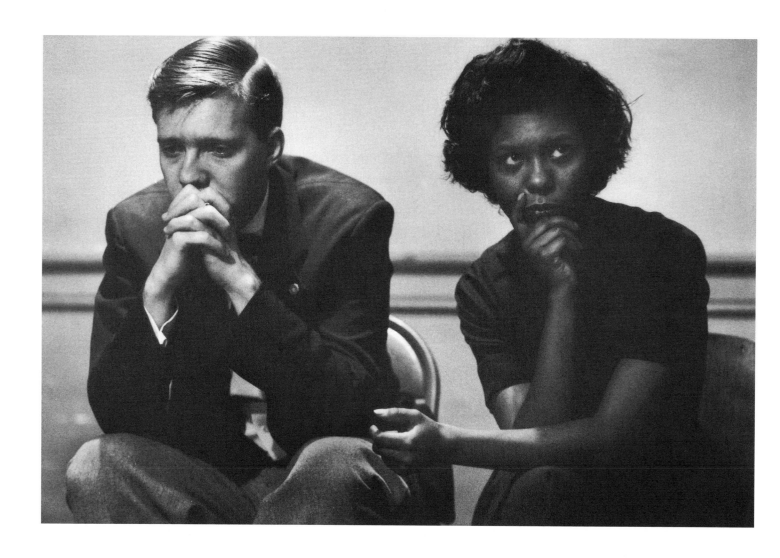

8. *Passive Resistance Training, Student Nonviolent*
Coordinating Committee (SNCC), Atlanta, 1960
$9^{1}/8 \times 13^{3}/4$ inches (23.2 cm × 34.9 cm)
Vintage gelatin silver print
Estate of James Karales

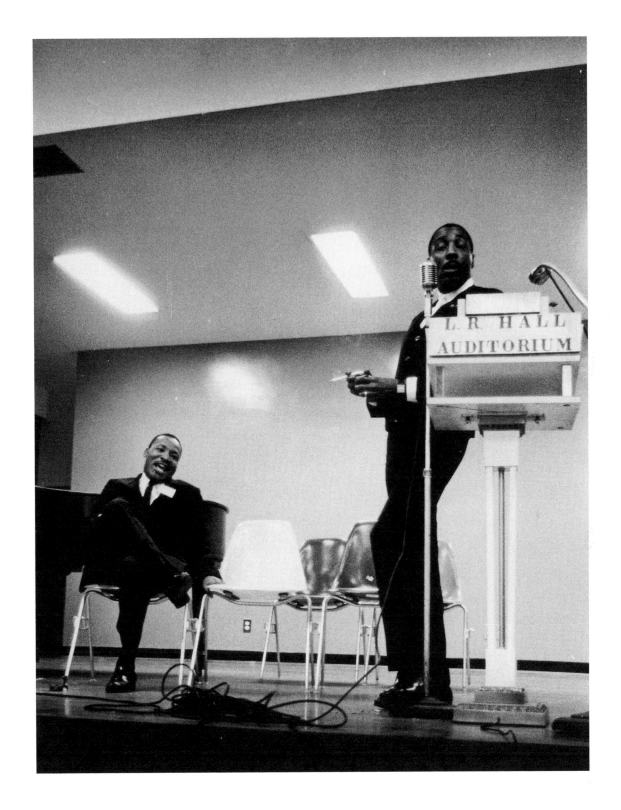

9. *SCLC Convention, Birmingham, 1962*
13¾ × 10¾ inches (34.9 × 27.3 cm)
Vintage gelatin silver print
Estate of James Karales

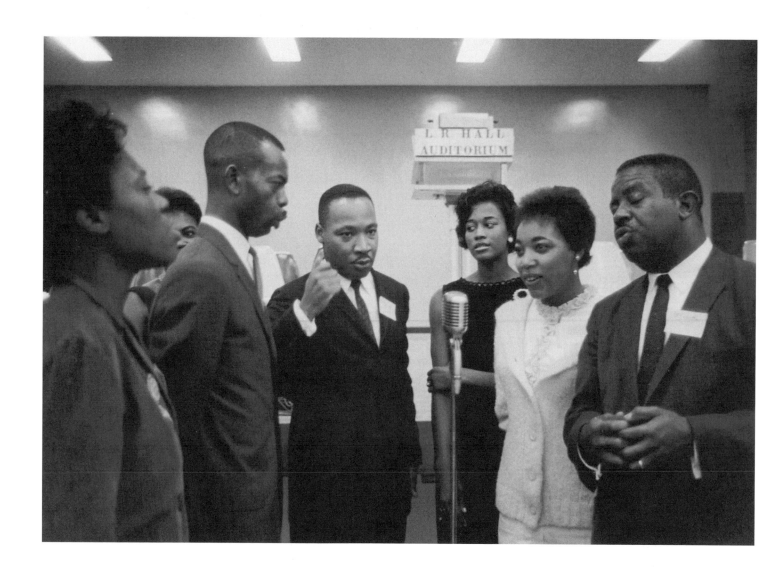

10. *Freedom Singing, SCLC Convention, Birmingham, 1962*
7 3/8 × 9 5/8 inches (17 × 24.6 cm)
Vintage gelatin silver print
Estate of James Karales

11. *Diane Nash, SCLC Convention, Birmingham, 1962*
6 ⅝ × 9 ⅝ inches (16.8 × 24.4 cm)
Vintage gelatin silver print
Estate of James Karales

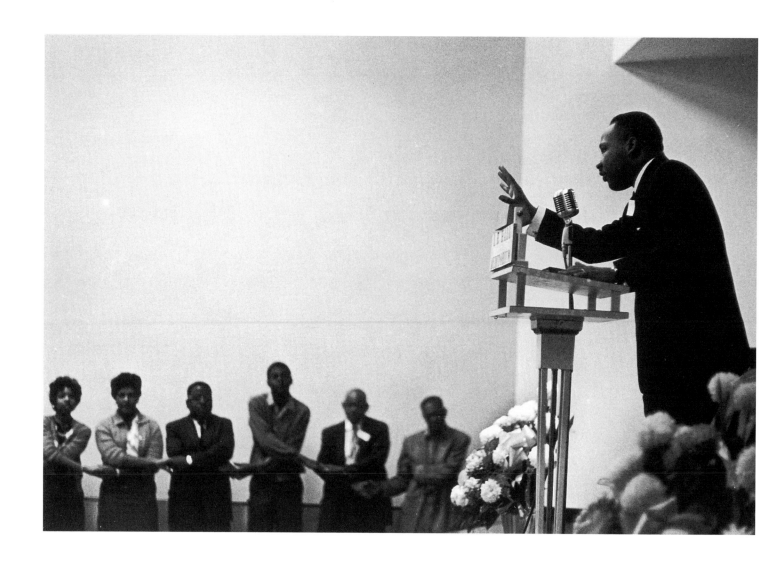

12. *Dr. Martin Luther King, Jr., SCLC Convention, Birmingham, 1962*
9³⁄₈ × 13⁵⁄₈ inches (23.7 × 35.6 cm)
Vintage gelatin silver print
Estate of James Karales

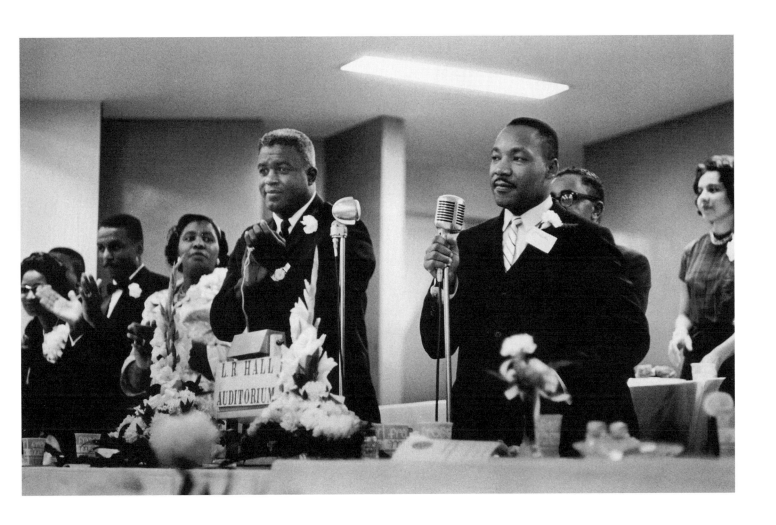

13. *Dr. Martin Luther King, Jr., with Jackie Robinson*
on his right, SCLC Convention, Birmingham, 1962
6 × 9⅝ inches (15.2 × 24.5 cm)
Vintage gelatin silver print
Estate of James Karales

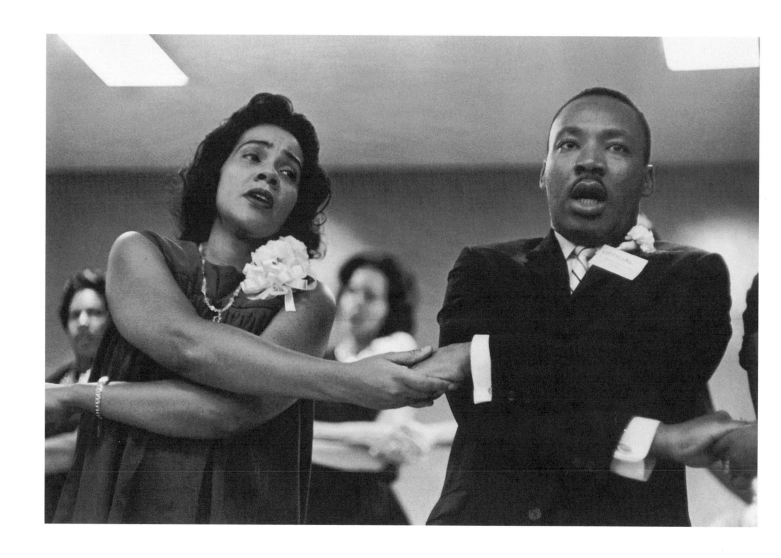

14. *Coretta Scott King and Dr. Martin Luther King, Jr.,*
Freedom Singing, SCLC Convention, Birmingham, 1962
6½ × 9½ inches (16.4 × 24.3 cm)
Vintage gelatin silver print
Estate of James Karales

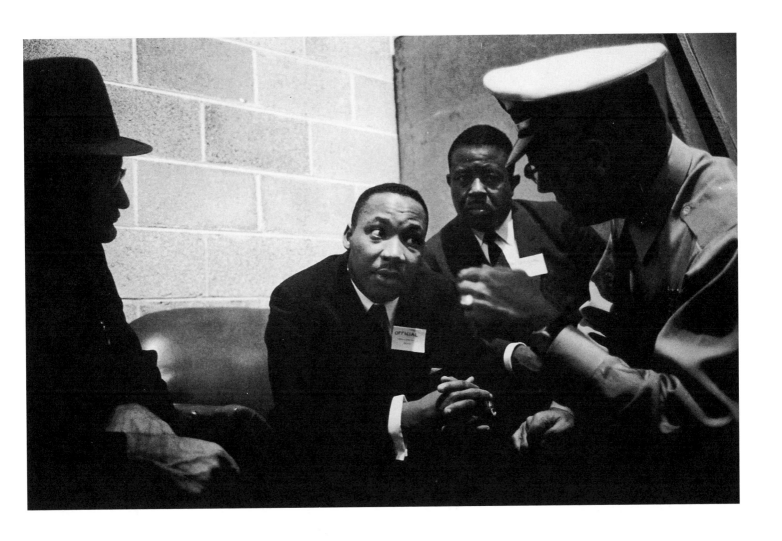

15. *Dr. Martin Luther King, Jr., in Discussion with Police*
after Assault, SCLC Convention, Birmingham, 1962
6¼ × 9¾ inches (16 × 24.5 cm)
Vintage gelatin silver print
Estate of James Karales

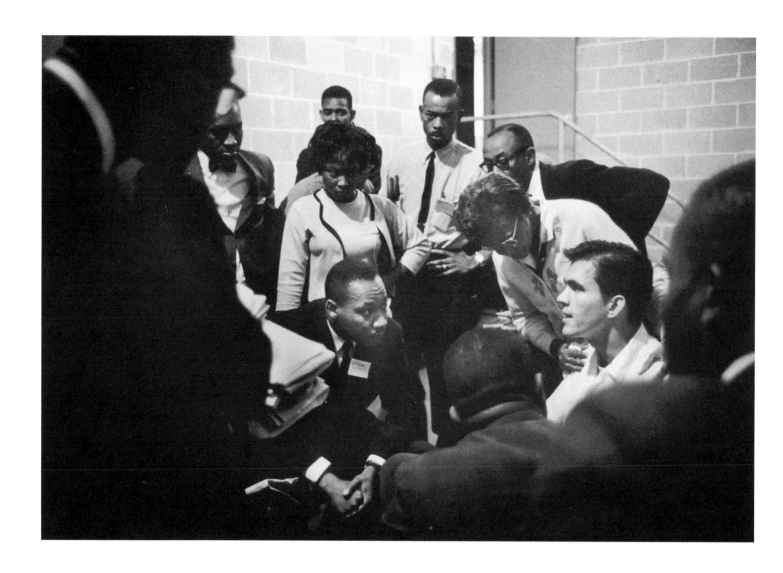

16. *Dr. Martin Luther King, Jr., in Discussion with*
His Attacker, SCLC Convention, Birmingham, 1962
6 3/4 × 9 5/8 inches (17 × 24.5 cm)
Vintage gelatin silver print
Estate of James Karales

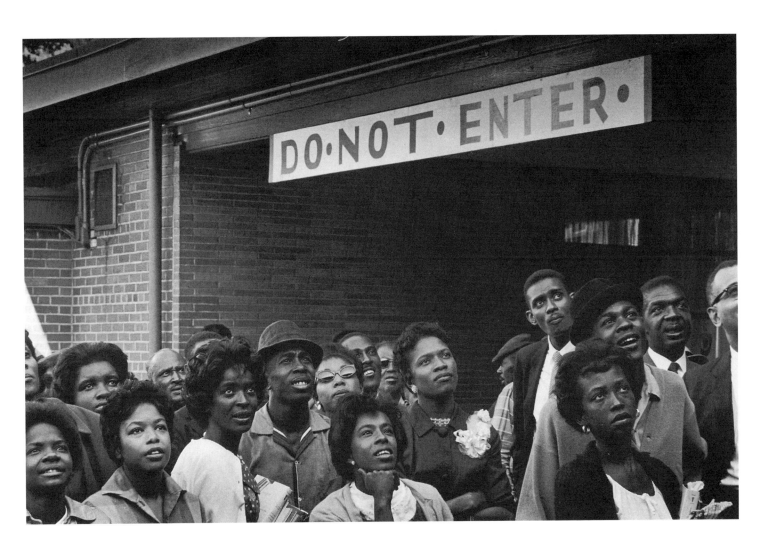

17. *Onlookers, Gaston Motel, Birmingham, 1962*
6³/8 × 9¹/2 inches (16.2 × 24.1 cm)
Vintage gelatin silver print
Estate of James Karales

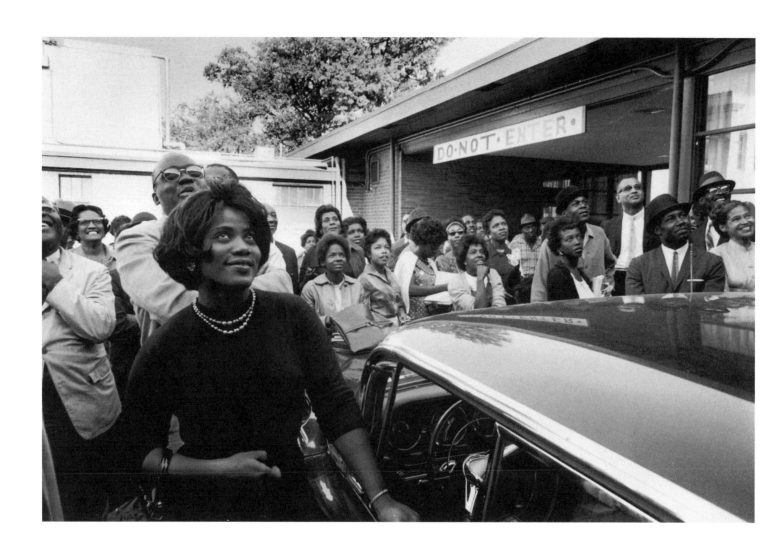

18. *Onlookers, Gaston Motel, Birmingham, 1962*
6 3/8 × 9 3/4 inches (16.2 × 24.6 cm)
Vintage gelatin silver print
Estate of James Karales

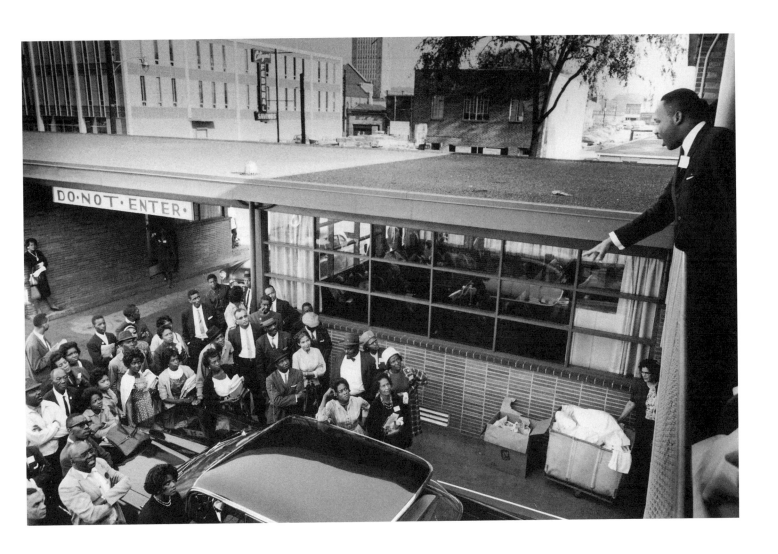

19. *Dr. King Addressing the Crowd, Gaston Motel, Birmingham, 1962*
4½ × 6¾ inches (11.4 × 16.9 cm)
Vintage gelatin silver print
Estate of James Karales

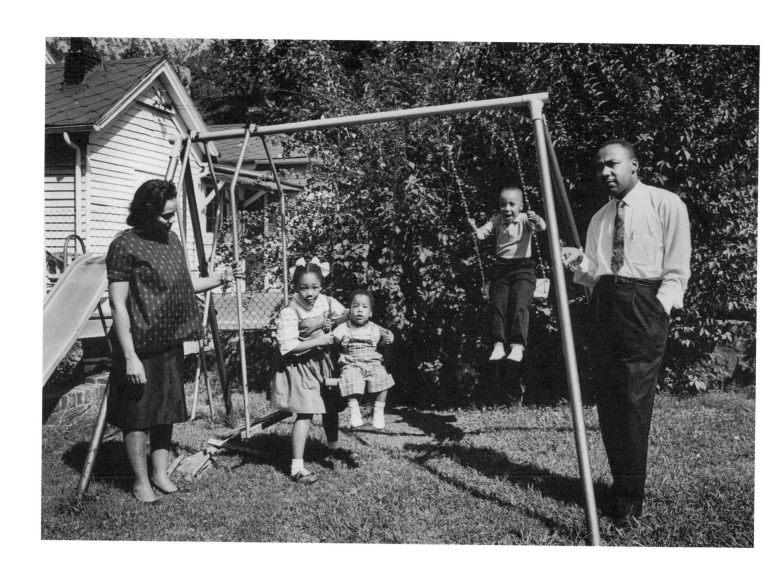

20. *The King Family at Home, Atlanta, 1962*
6 5/8 × 9 5/8 inches (16.6 × 24.3 cm)
Vintage gelatin silver print
High Museum of Art, Atlanta

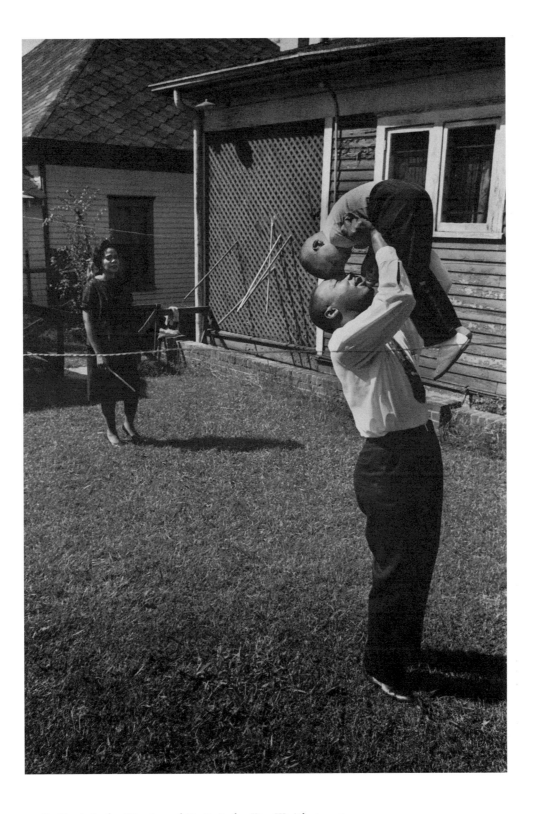

21. *Dr. Martin Luther King, Jr., and Martin Luther King III, Atlanta, 1962*
13 5/8 × 7 7/8 inches (34.5 × 20 cm)
Vintage gelatin silver print
Estate of James Karales

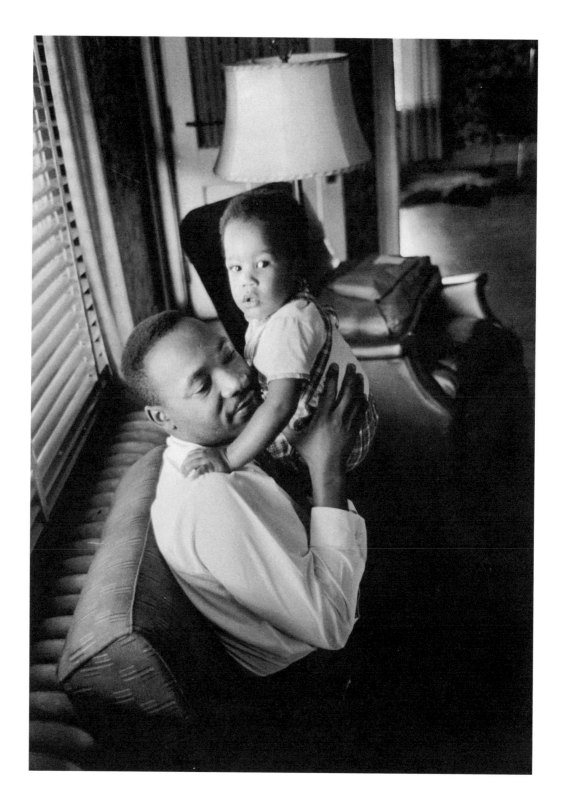

22. *Dr. Martin Luther King, Jr., and Dexter Scott King, Atlanta, 1962*
13¾ × 9¾ inches (34.7 × 24.7 cm)
Vintage gelatin silver print
Estate of James Karales

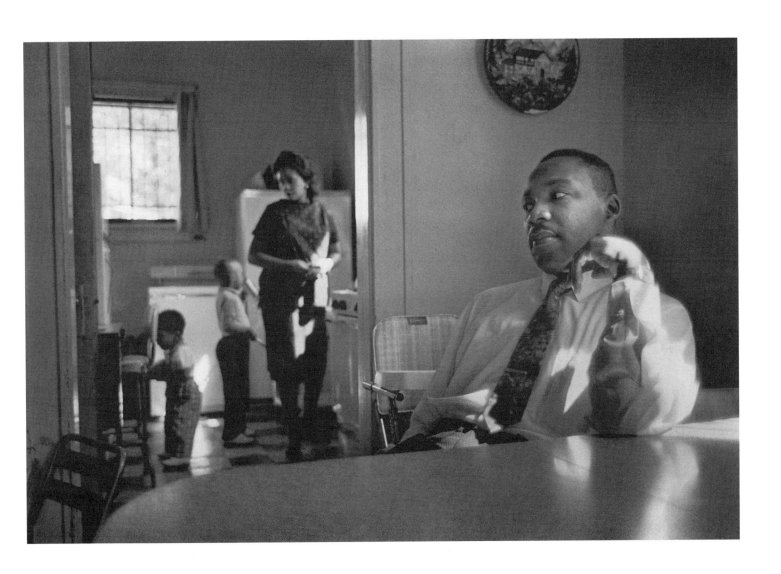

23. *The King Family at Home, Atlanta, 1962*
Vintage gelatin silver print
6 5/8 × 9 5/8 inches (16.6 × 24.3 cm)
Estate of James Karales

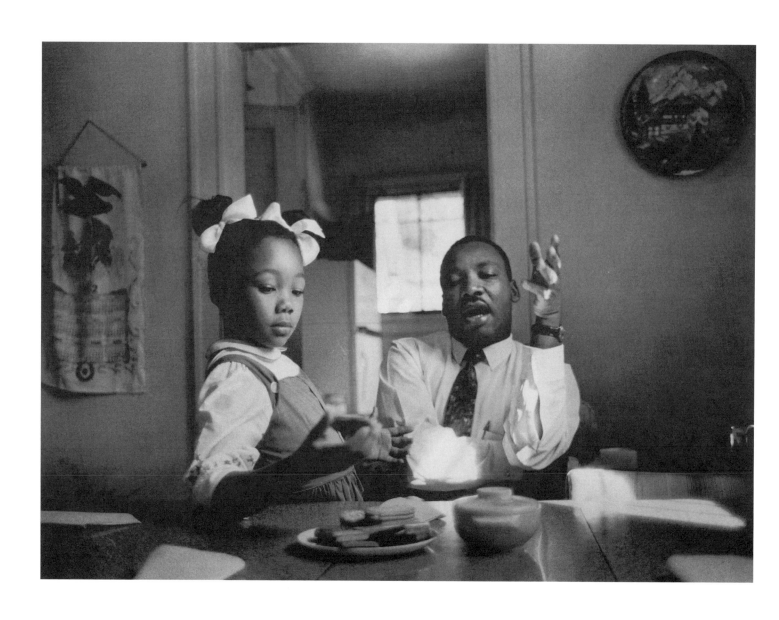

24. *Dr. Martin Luther King, Jr., and Yolanda King, Atlanta, 1962*
9⅝ × 13¾ inches (24.5 × 34.8 cm)
Vintage gelatin silver print
Estate of James Karales

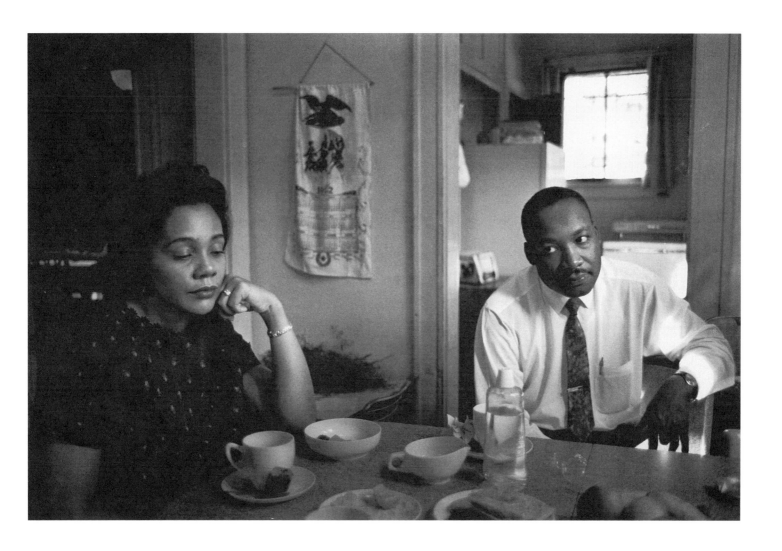

25. *Coretta Scott King and Dr. Martin Luther King, Jr., Atlanta, 1962*
6 ⅝ × 9 ⅜ inches (16.6 × 24.3 cm)
Vintage gelatin silver print
Howard Greenberg Gallery, New York

26. *Dr. Martin Luther King, Jr., Birmingham Airport, 1962*
6$\frac{1}{2}$ × 9$\frac{1}{2}$ inches (16.4 × 24.3 cm)
Vintage gelatin silver print
Estate of James Karales

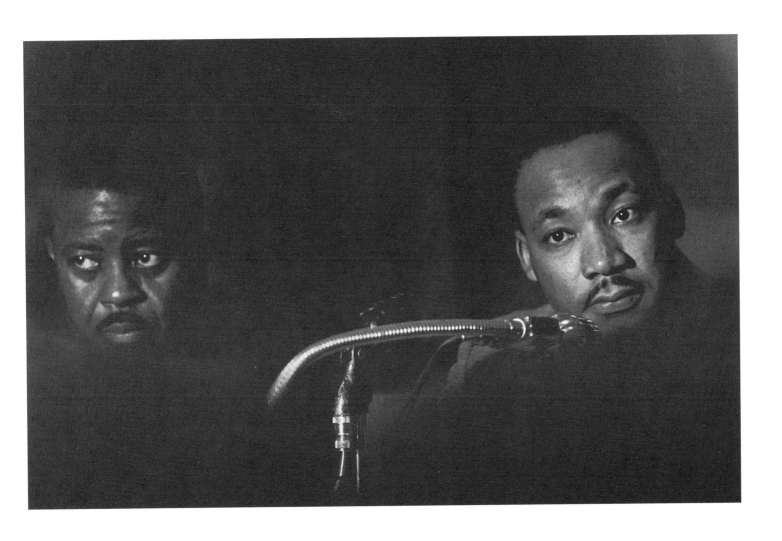

27. *Rev. Ralph Abernathy and Dr. Martin Luther King, Jr., Birmingham, 1962*
6 $^1/_8$ × 9 $^1/_2$ inches (15.6 × 24.1 cm)
Vintage gelatin silver print
Howard Greenberg Gallery, New York

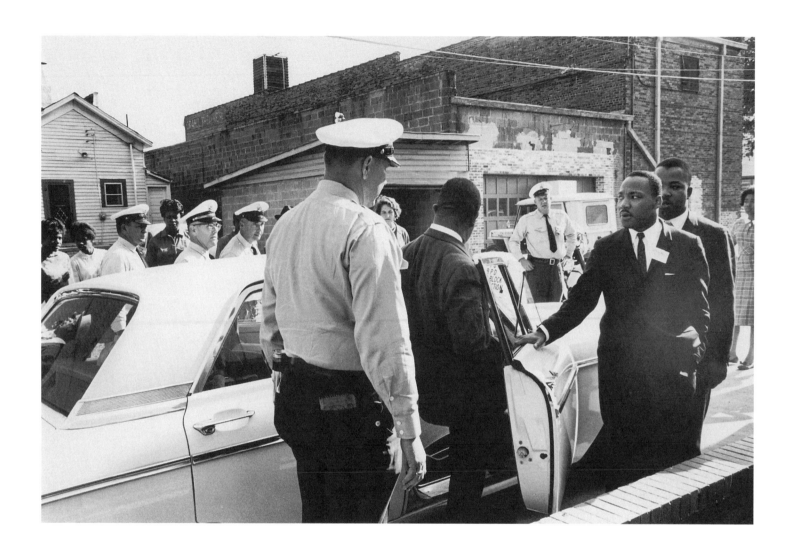

28. *Birmingham Police Escorting Rev. Ralph Abernathy and*
Dr. Martin Luther King, Jr., for Questioning, Birmingham, 1962
6½ × 9¾ inches (16.4 × 24.6 cm)
Vintage gelatin silver print
Estate of James Karales

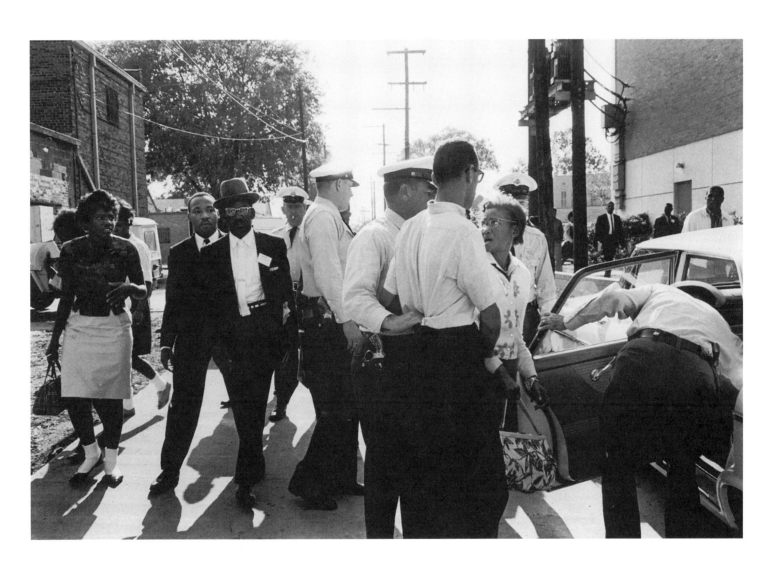

29. *Arrest of Wyatt "Tee" Walker, Birmingham, 1962*
6 5/8 × 9 5/8 inches (16.5 × 24.5 cm)
Vintage gelatin silver print
Estate of James Karales

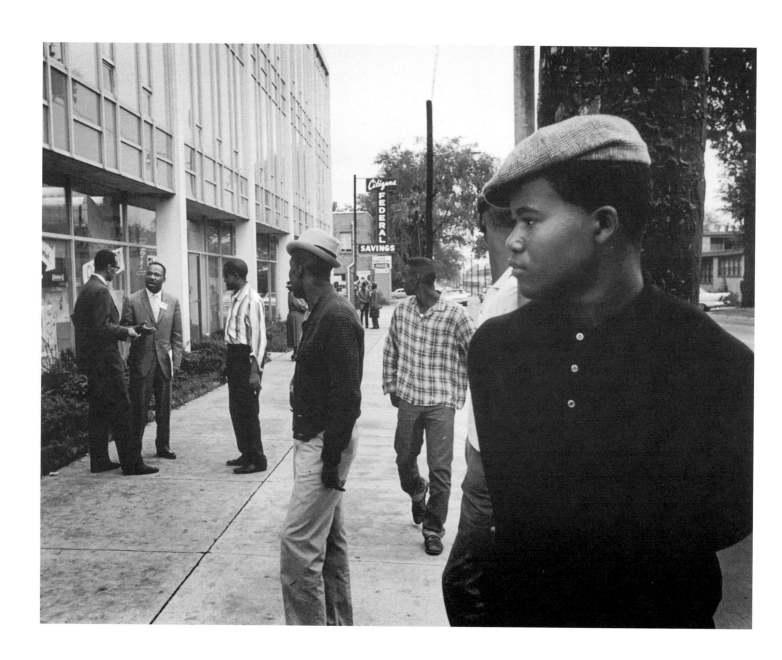

30. *Dr. Martin Luther King, Jr., Conferring with*
Wyatt "Tee" Walker, Birmingham, 1962
7¾ × 9⅝ inches (19.3 × 24.5 cm)
Vintage gelatin silver print
Estate of James Karales

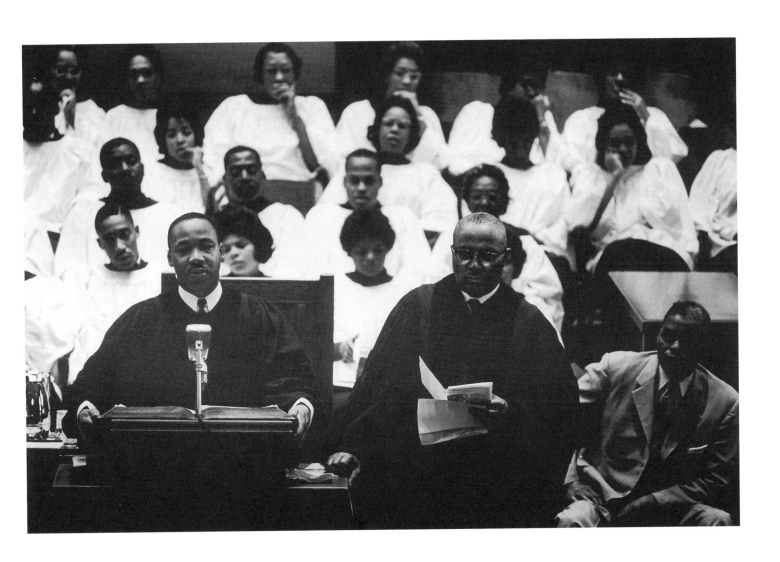

31. *Dr. Martin Luther King, Jr., and Daddy King,*
Ebenezer Baptist Church, Atlanta, 1962
9¹⁄₈ × 13¾ inches (23 × 34.7 cm)
Vintage gelatin silver print
Estate of James Karales

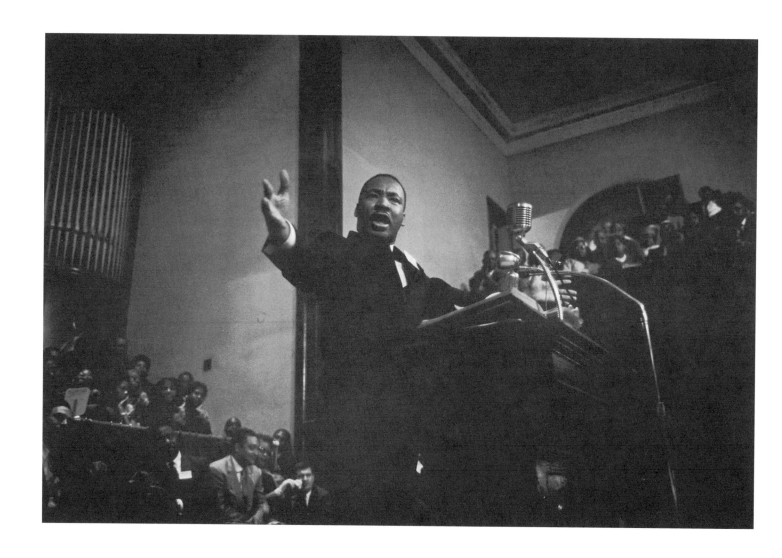

32. *Dr. Martin Luther King, Jr., Addressing a Rally,*
Sixteenth Street Baptist Church, Birmingham, 1963
6 3/8 × 9 5/8 inches (16.2 × 24.2 cm)
Vintage gelatin silver print
Estate of James Karales

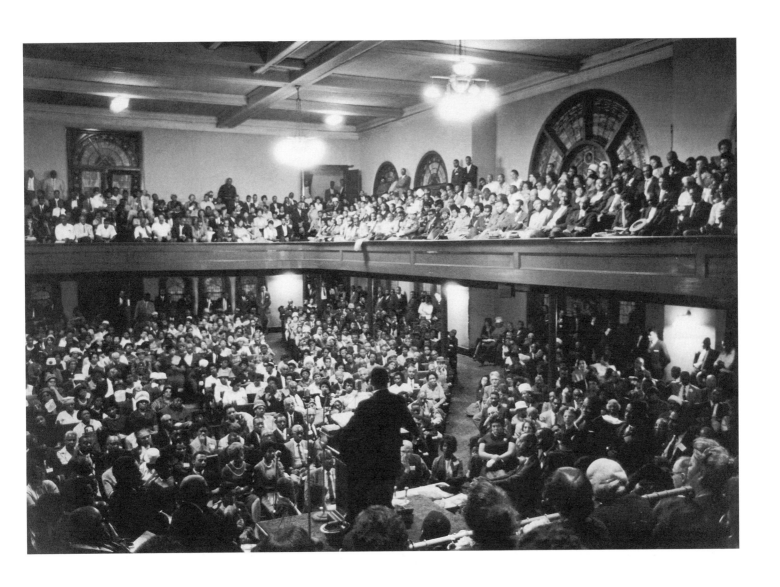

33. *Dr. Martin Luther King, Jr., Addressing a Rally,*
Sixteenth Street Baptist Church, Birmingham, 1963
6¾ × 9⅝ inches (17 × 24.5 cm)
Vintage gelatin silver print
Estate of James Karales

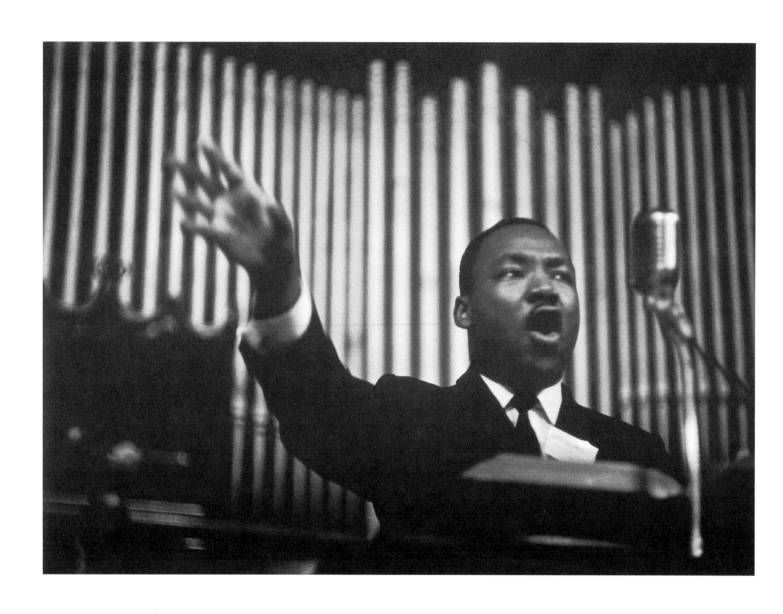

34. *Dr. Martin Luther King, Jr., Addressing a Rally,*
Sixteenth Street Baptist Church, Birmingham, 1963
4½ × 6¾ inches (11.5 × 17 cm)
Vintage gelatin silver print
Estate of James Karales

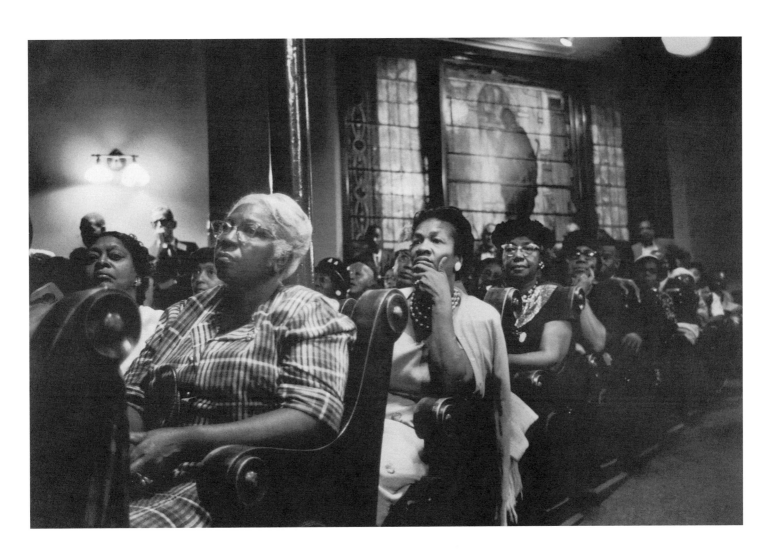

35. *Congregation, Sixteenth Street Baptist Church, Birmingham, 1963*
6¼ × 9⅝ inches (16 × 24.5 cm)
Vintage gelatin silver print
Estate of James Karales

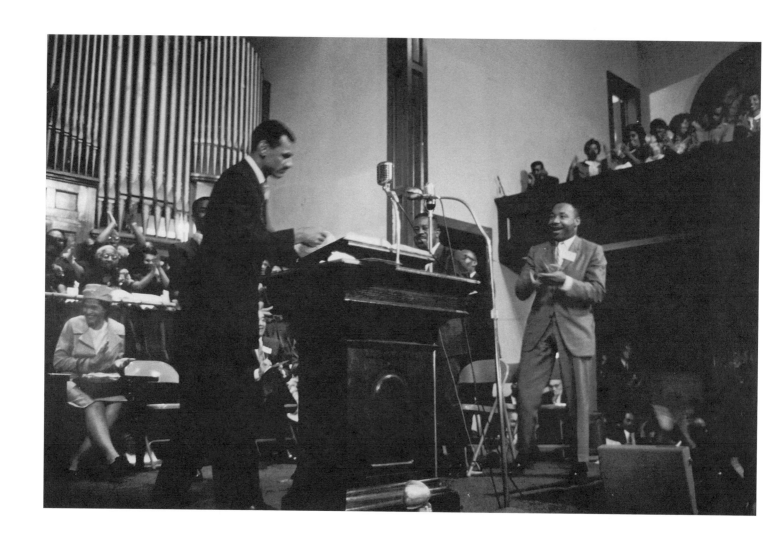

36. *Rev. C. T. Vivian Approaching the Lectern at*
Sixteenth Street Baptist Church, Birmingham, 1963
6³/₈ × 9¹/₂ inches (16.3 × 25.2 cm)
Vintage gelatin silver print
Estate of James Karales

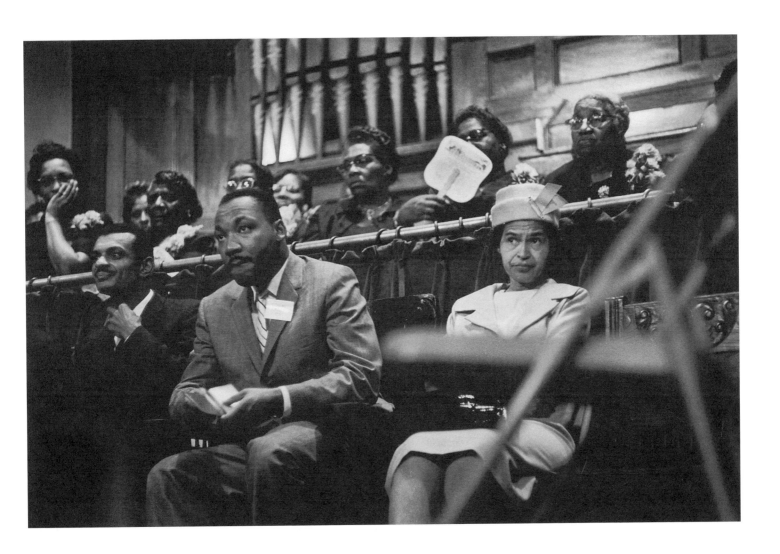

37. *Rev. C. T. Vivian, Dr. Martin Luther King, Jr., and Rosa Parks,*
Sixteenth Street Baptist Church, Birmingham, 1963
7¹/₈ × 9³/₄ inches (18.1 × 24.5 cm)
Vintage gelatin silver print
Estate of James Karales

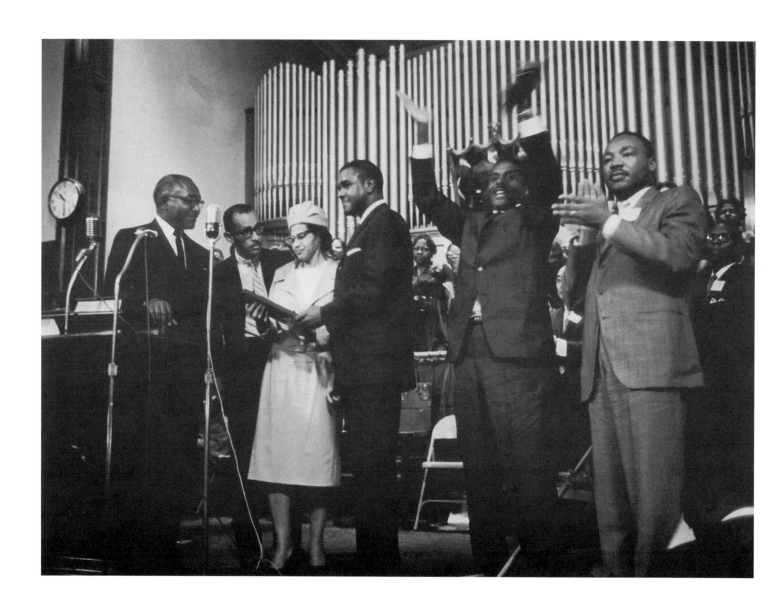

38. *Rosa Parks and Other Civil Rights Leaders,*
Sixteenth Street Baptist Church, Birmingham, 1963
$6^{3}/_{8} \times 9^{1}/_{2}$ inches (16.2 × 24.3 cm)
Vintage gelatin silver print
Estate of James Karales

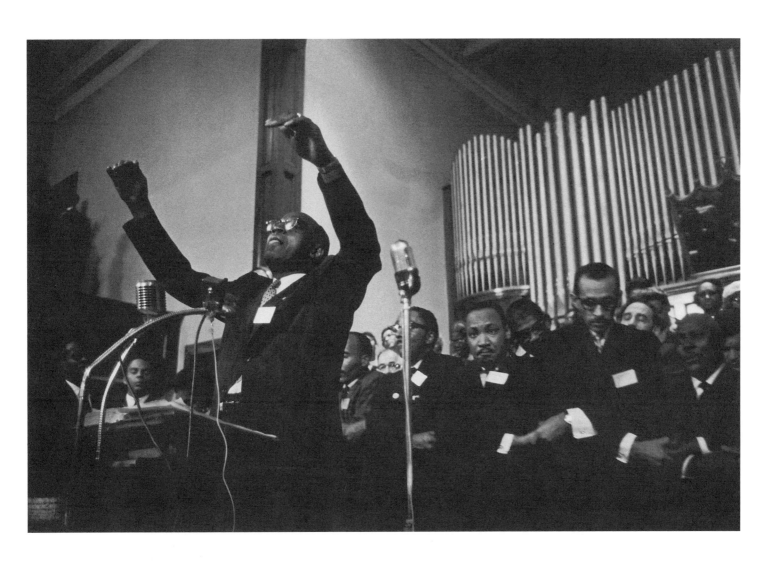

39. Singing "We Shall Overcome," Sixteenth
Street Baptist Church, Birmingham, 1963
6³⁄8 × 9¹⁄2 inches (16.3 × 24.3 cm)
Vintage gelatin silver print
Estate of James Karales

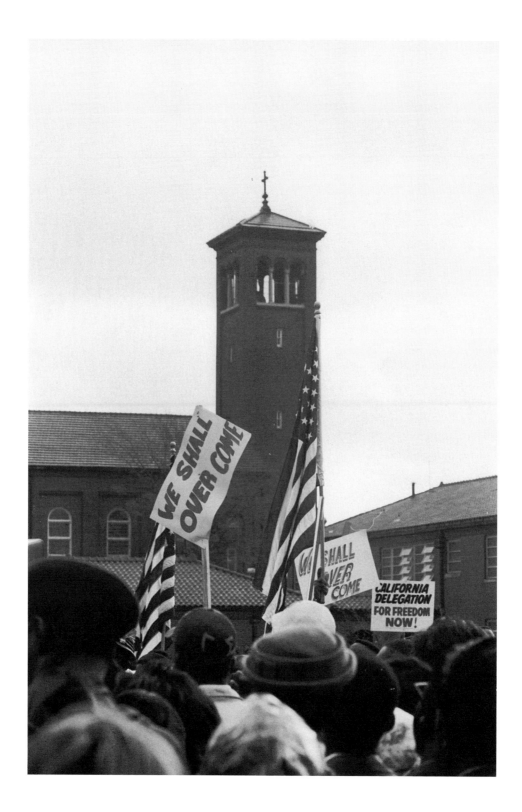

40. *Massed Demonstrators Awaiting Selma to Montgomery*
March, Brown Chapel AME Church, Selma, 1965
Digital scan from original 35mm negative
Rare Book, Manuscript, and Special Collections Library, Duke University

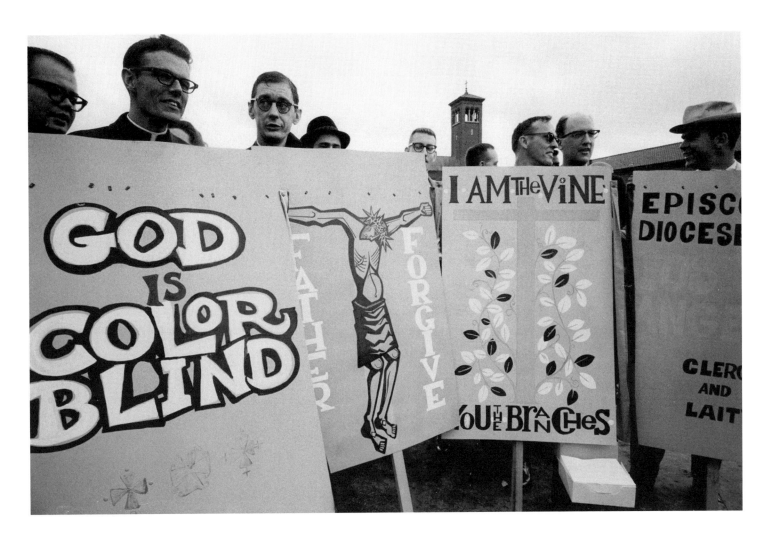

41. *Episcopalian Clergy, Selma to Montgomery March, Selma, 1965*
Digital scan from original 35mm negative
Rare Book, Manuscript, and Special Collections Library, Duke University

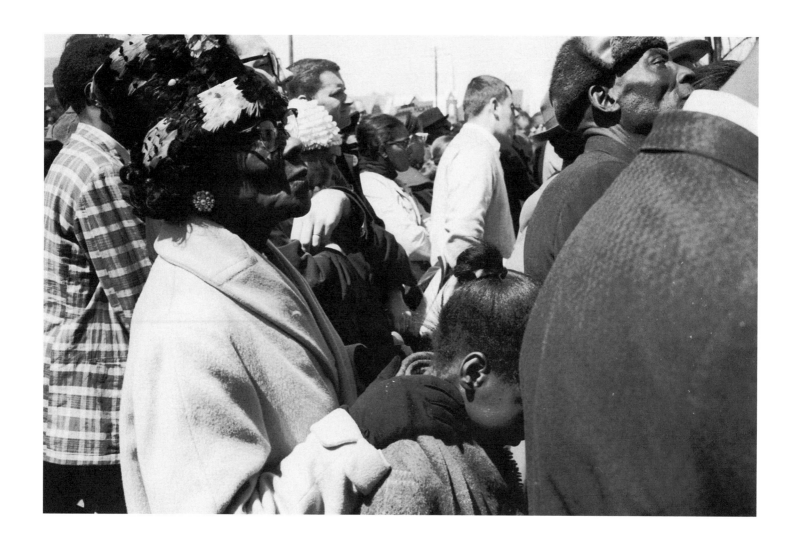

42. *Faces in the Crowd, Selma to Montgomery March, 1965*
Digital scan from original 35mm negative
Rare Book, Manuscript, and Special Collections Library, Duke University

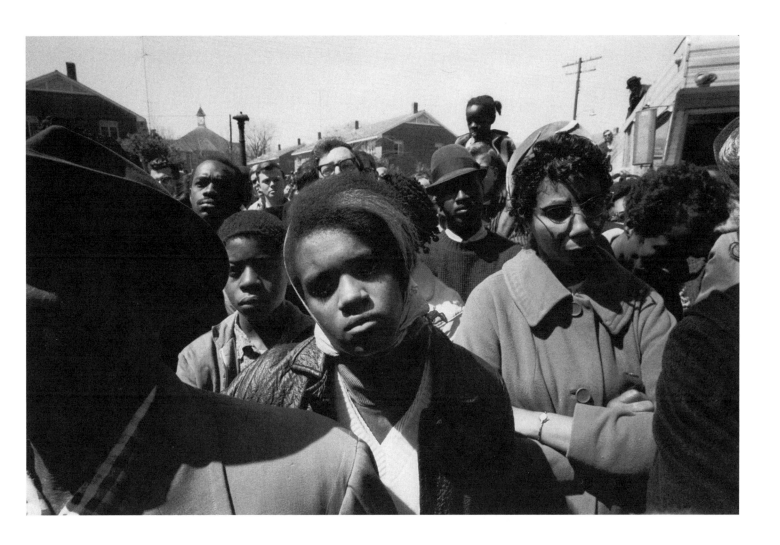

43. *Faces in the Crowd, Selma to Montgomery March, 1965*
Digital scan from original 35mm negative
Rare Book, Manuscript, and Special Collections Library, Duke University

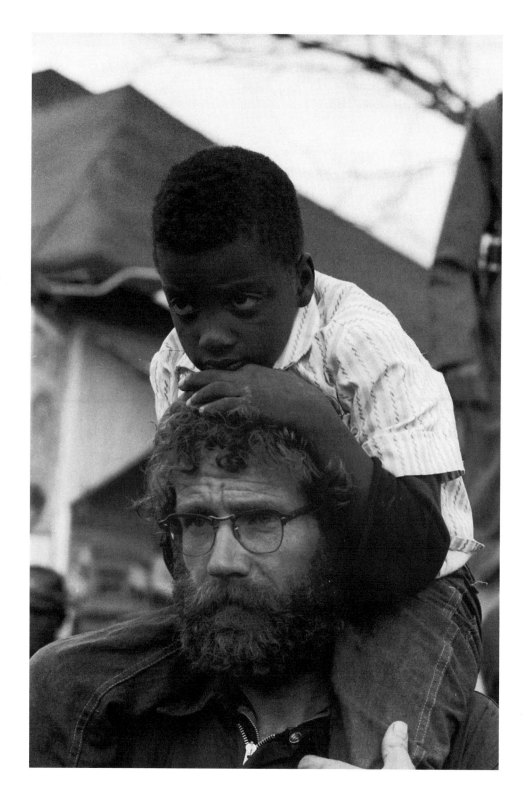

44. *Faces in the Crowd, Selma to Montgomery March, 1965*
9 ⁵⁄₈ × 7 ¹⁄₈ inches (24.5 × 18 cm)
Vintage gelatin silver print
Estate of James Karales

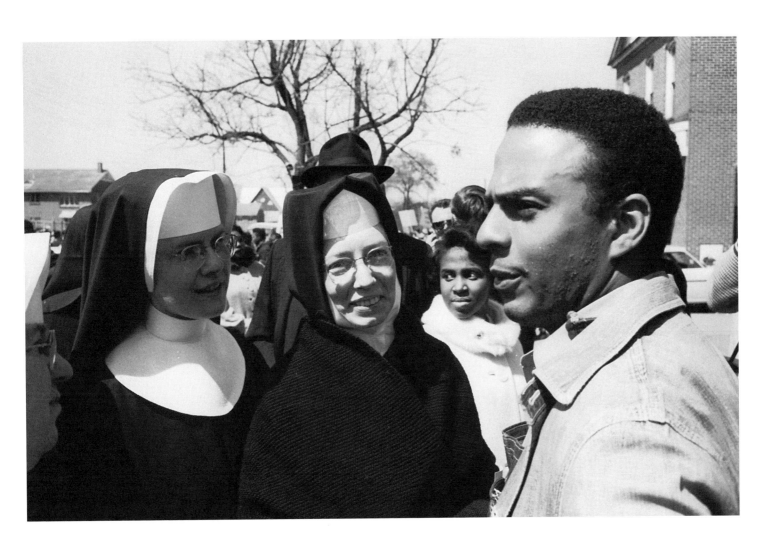

45. *Unidentified Nun, Sister Mary Leoline, and Andrew Young,*
Selma to Montgomery March, 1965
Digital scan from original 35mm negative
Rare Book, Manuscript, and Special Collections Library, Duke University

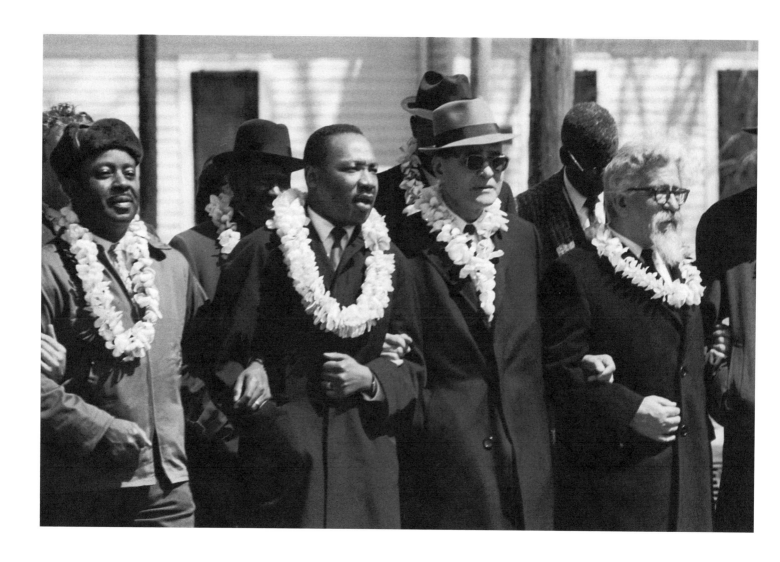

46. Rev. Ralph Abernathy, Dr. Martin Luther King, Jr., Rabbi Maurice Eisendrath,
and Rabbi Abraham Heschel, Selma to Montgomery March, 1965
Digital scan from original 35mm negative
Rare Book, Manuscript, and Special Collections Library, Duke University

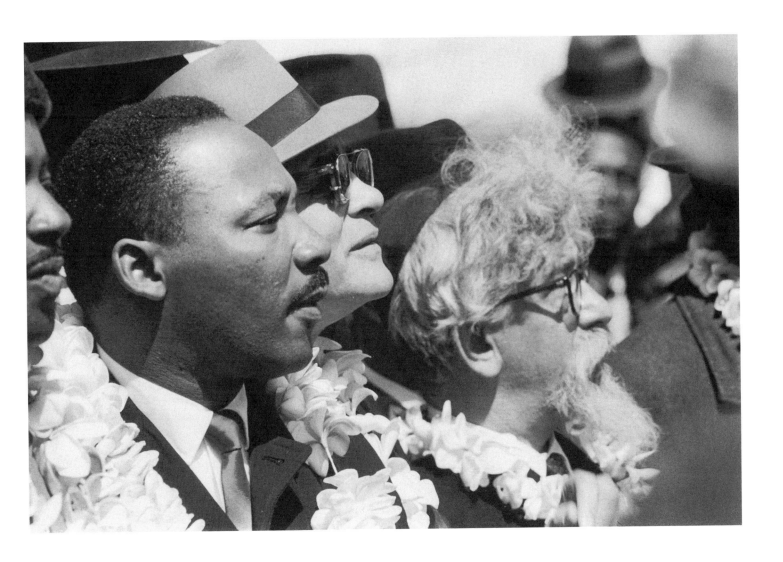

47. *Rev. Ralph Abernathy, Dr. Martin Luther King, Jr., Rabbi Maurice Eisendrath,*
and Rabbi Abraham Heschel, Selma to Montgomery March, 1965
4 × 5¹⁄₂ inches (9.6 × 14.1 cm)
Vintage gelatin silver print
Estate of James Karales

48. *John Lewis and Sister Mary Leoline Hand in Hand,*
Selma to Montgomery March, 1965
Digital scan from original 35mm negative
Rare Book, Manuscript, and Special Collections Library, Duke University

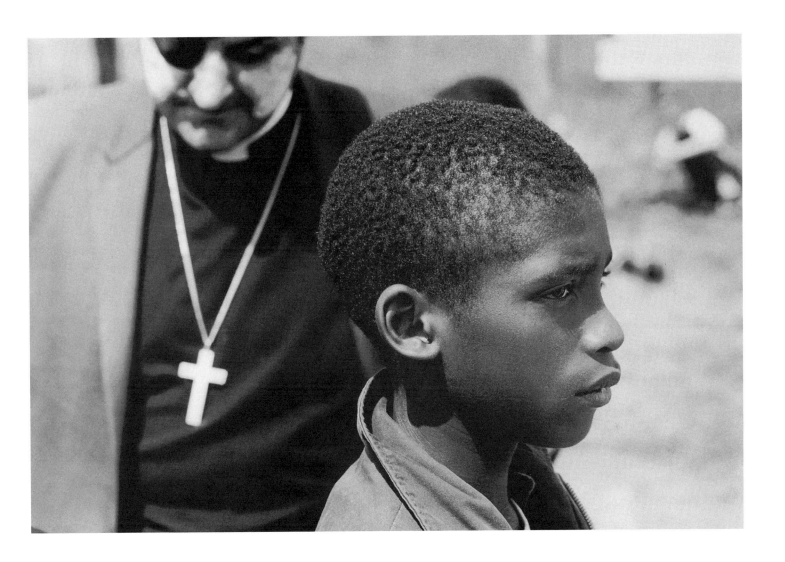

49. *Father Dominic Orsini and Young Marcher, Selma to Montgomery March, 1965*
9 × 13¼ inches (22.7 × 33.8 cm)
Modern gelatin silver print
Estate of James Karales

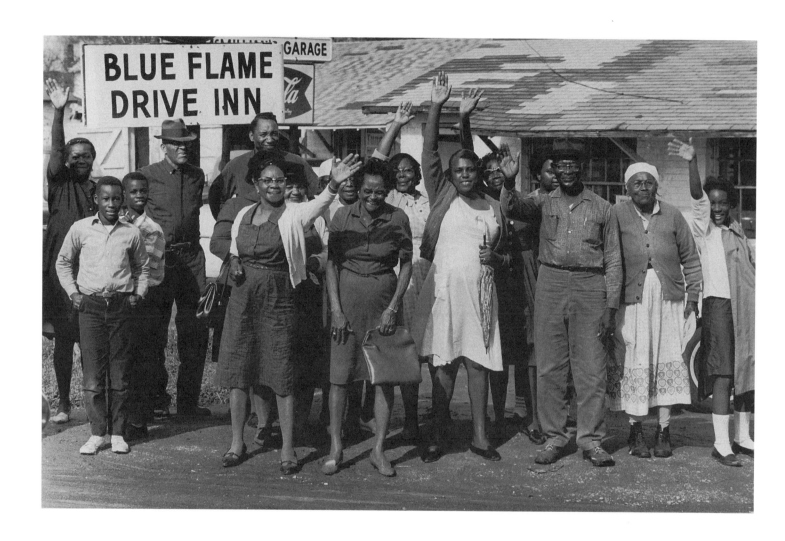

50. *Onlookers, Selma to Montgomery March, 1965*
6¼ × 9⅝ inches (16 × 24.6 cm)
Vintage gelatin silver print
Estate of James Karales

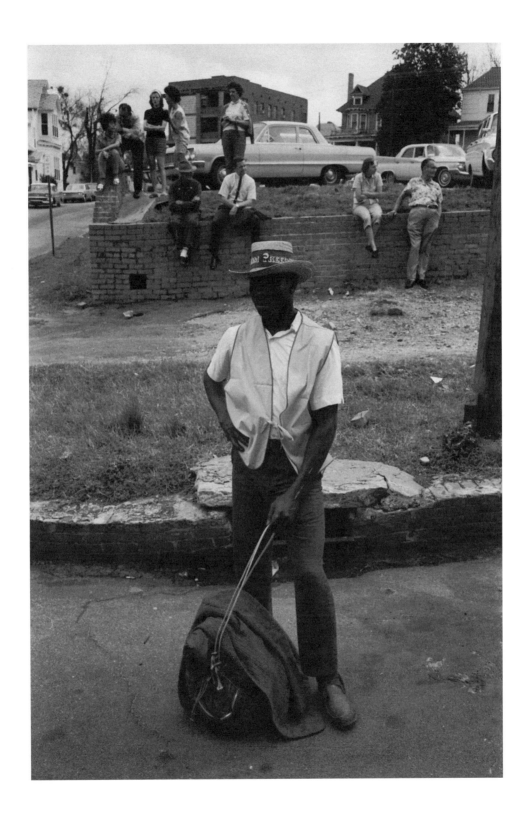

51. *Young Marcher, Selma to Montgomery March, 1965*
Digital scan from original 35mm negative
Rare Book, Manuscript, and Special Collections Library, Duke University

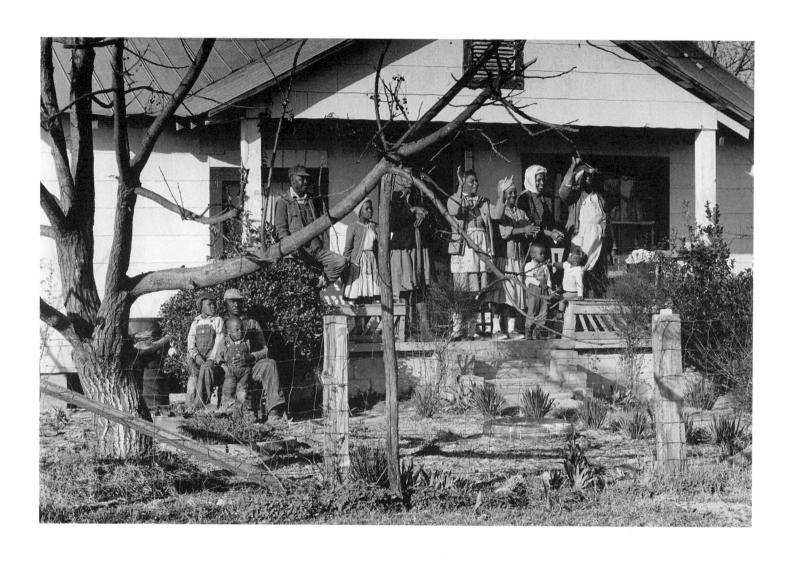

52. *Onlookers, Selma to Montgomery March, 1965*
8⁷⁄₈ × 13³⁄₈ inches (22.7 × 34 cm)
Modern gelatin silver print
Estate of James Karales

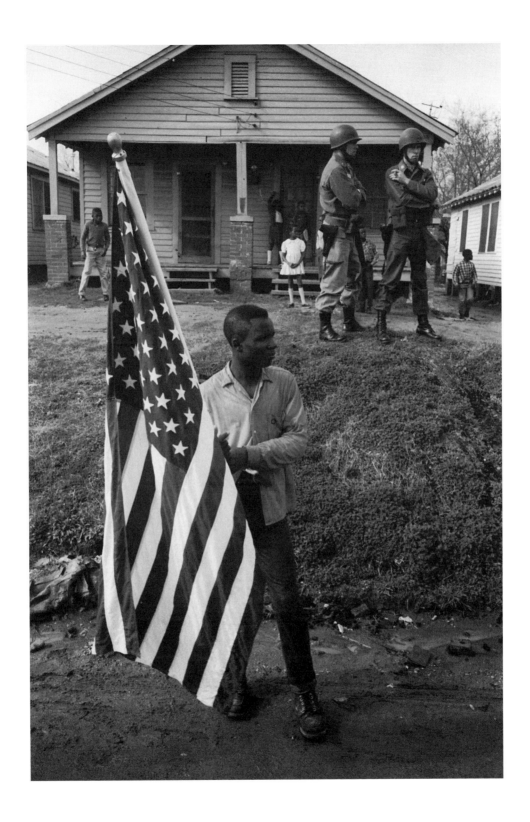

53. *Young Marcher, Selma to Montgomery March, 1965*
Digital scan from original 35mm negative
Rare Book, Manuscript, and Special Collections Library, Duke University

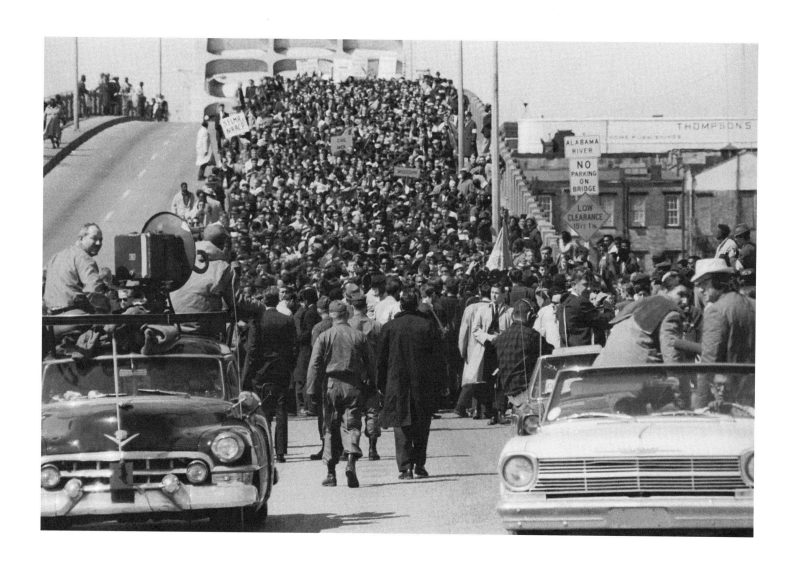

54. *Marchers Crossing the Edmund Pettus Bridge, Selma, 1965*
Digital scan from original 35mm negative
Rare Book, Manuscript, and Special Collections Library, Duke University

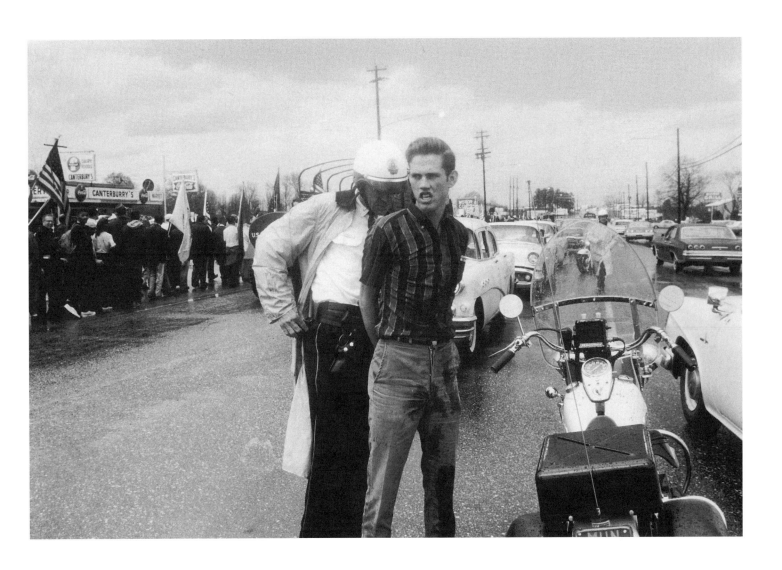

55. *Young Segregationist Arrested, Selma, 1965*
6 × 8⅞ inches (15.2 × 22.5 cm)
Vintage gelatin silver print
Estate of James Karales

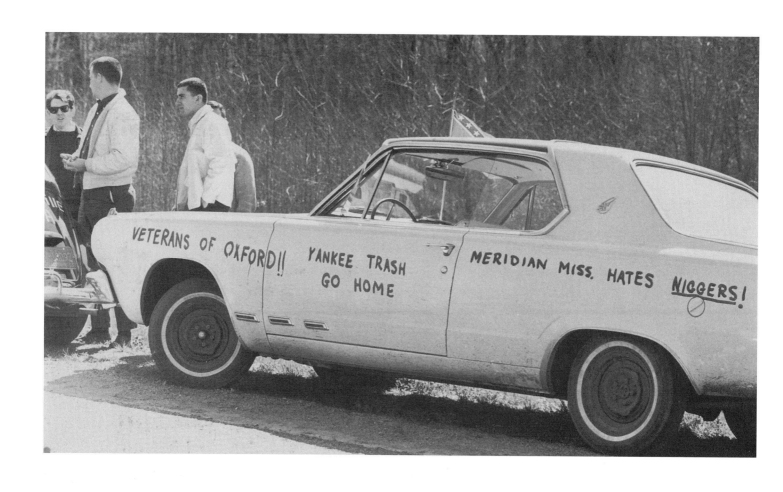

56. Segregationists Parked on Highway 80, Selma to Montgomery March, 1965
5¼ × 9¼ inches (13.4 × 23.4 cm)
Vintage gelatin silver print
Estate of James Karales

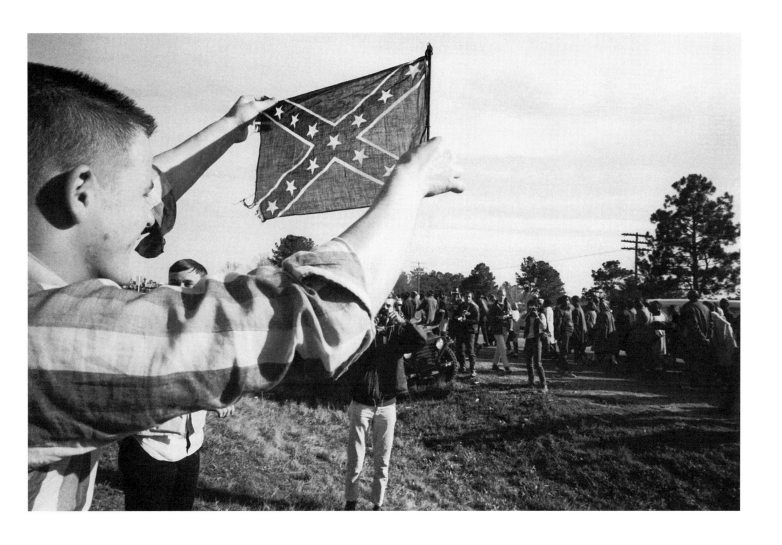

57. *Segregationist Taunting Marchers, Selma to Montgomery March, 1965*
Digital scan from original 35mm negative
Rare Book, Manuscript, and Special Collections Library, Duke University

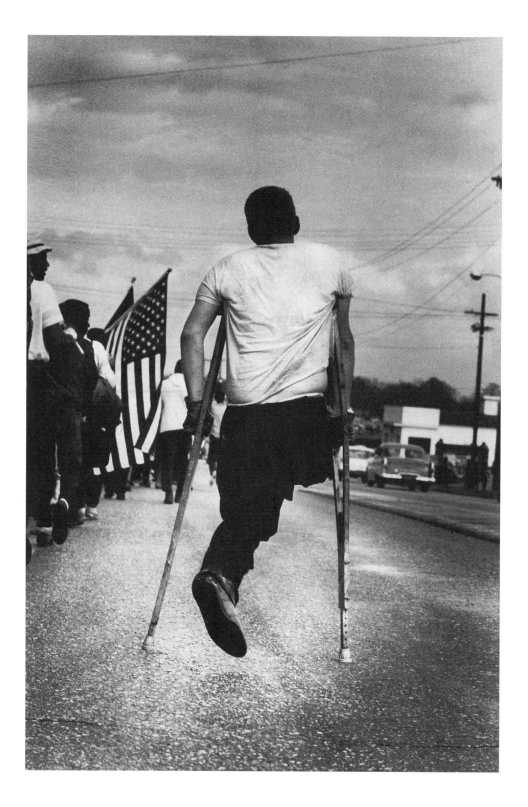

58. *Jim Letherer, Selma to Montgomery March, 1965*
9 7/8 × 6 3/8 inches (24 × 16.2 cm)
Vintage gelatin silver print
High Museum of Art, Atlanta

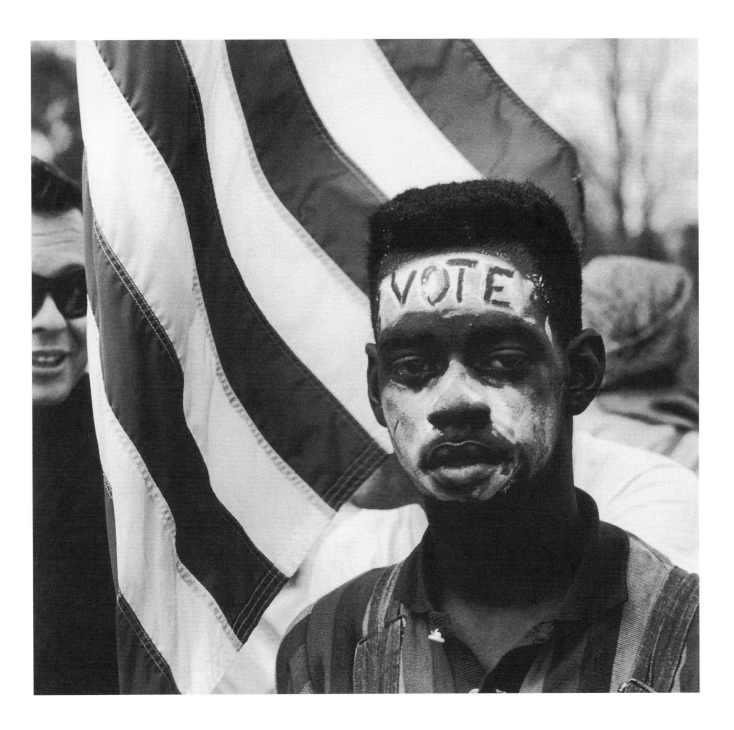

59. *Bobby Simmons, Selma to Montgomery March, 1965*
10⁷/8 × 13⁵/8 inches (27.4 × 34.7 cm)
Vintage gelatin silver print
Estate of James Karales

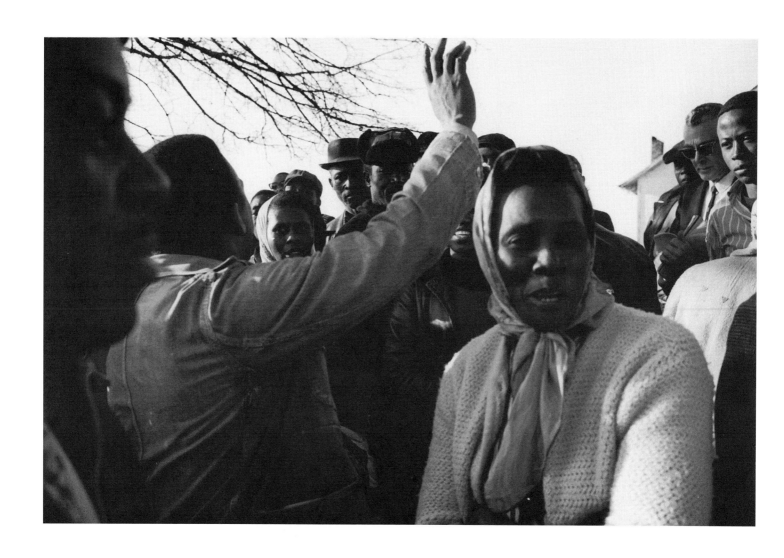

60. *Andrew Young Addressing Marchers, Selma to Montgomery March, 1965*
Digital scan from original 35mm negative
Rare Book, Manuscript, and Special Collections Library, Duke University

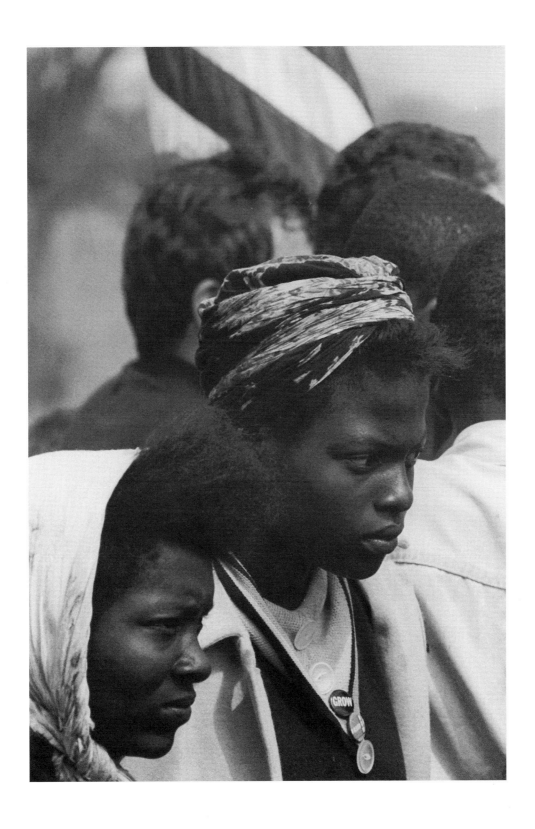

61. *Young Marchers, Selma to Montgomery March, 1965*
Digital scan from original 35mm negative
Rare Book, Manuscript, and Special Collections Library, Duke University

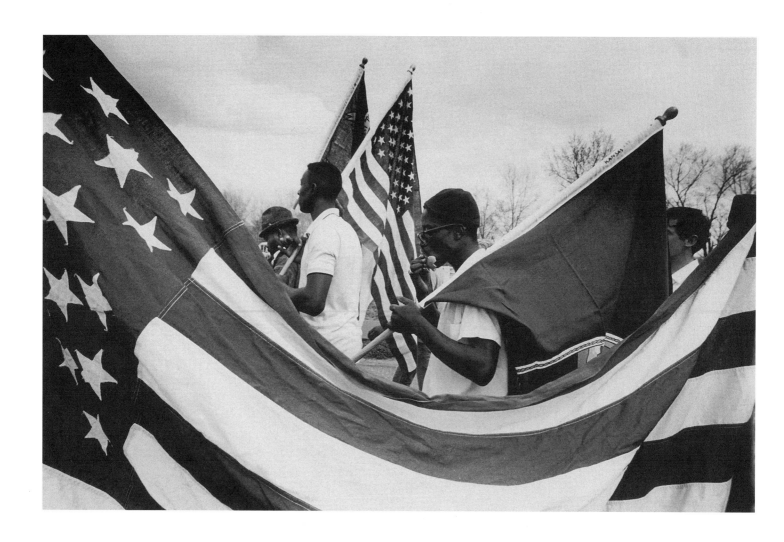

62. *Flag-Bearing Marchers, Selma to Montgomery March, 1965*
8⁶/8 × 13¹/4 inches (22.2 × 22.7 cm)
Modern gelatin silver print
Estate of James Karales

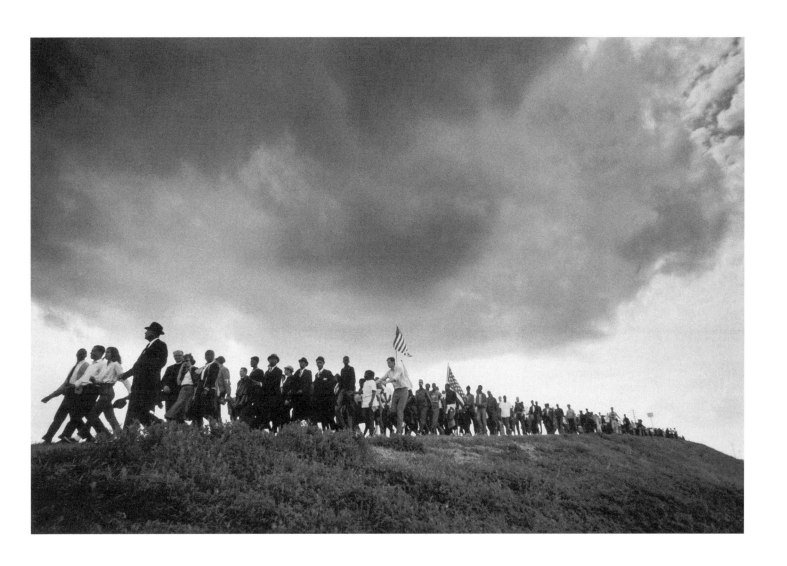

63. *Selma to Montgomery March, 1965*
12 × 16¾ inches (30.5 × 43.2 cm)
Vintage gelatin silver print
Estate of James Karales

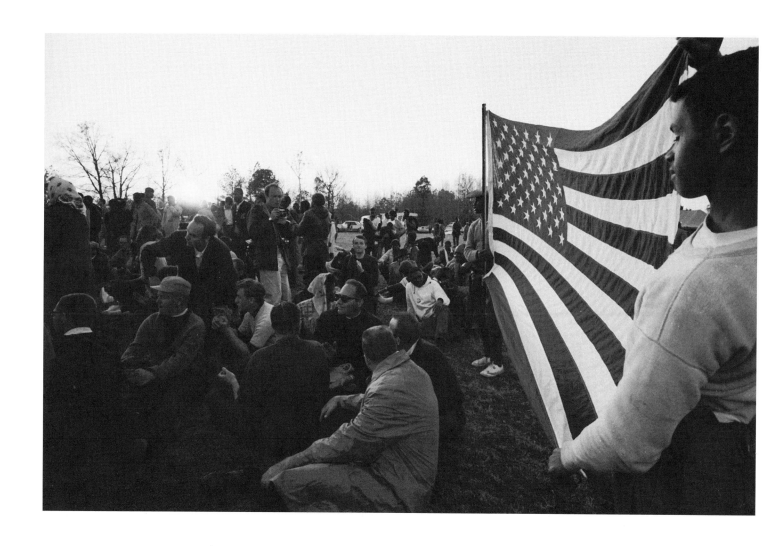

64. *Marchers Settling at Camp, Selma to Montgomery March, 1965*
Digital scan from original 35mm negative
Rare Book, Manuscript, and Special Collections Library, Duke University

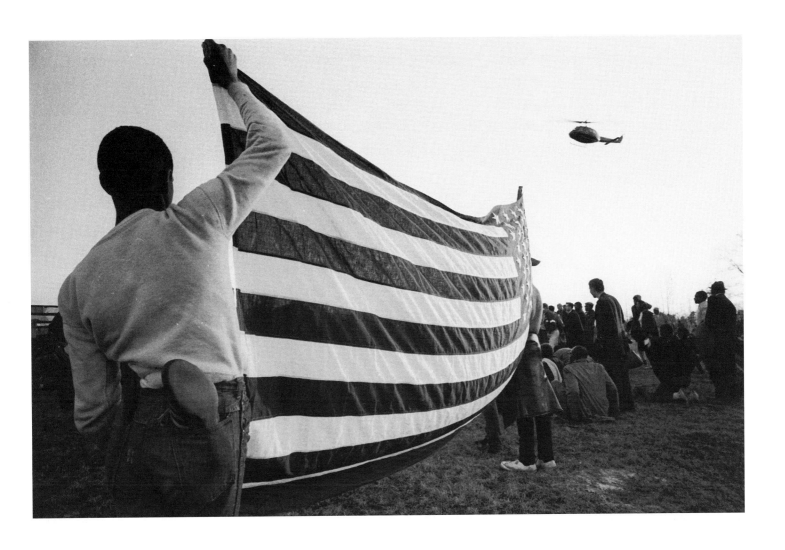

65. *Marchers Settling at Camp with National Guard*
Helicopter Overhead, Selma to Montgomery March, 1965
Digital scan from original 35mm negative
Rare Book, Manuscript, and Special Collections Library, Duke University

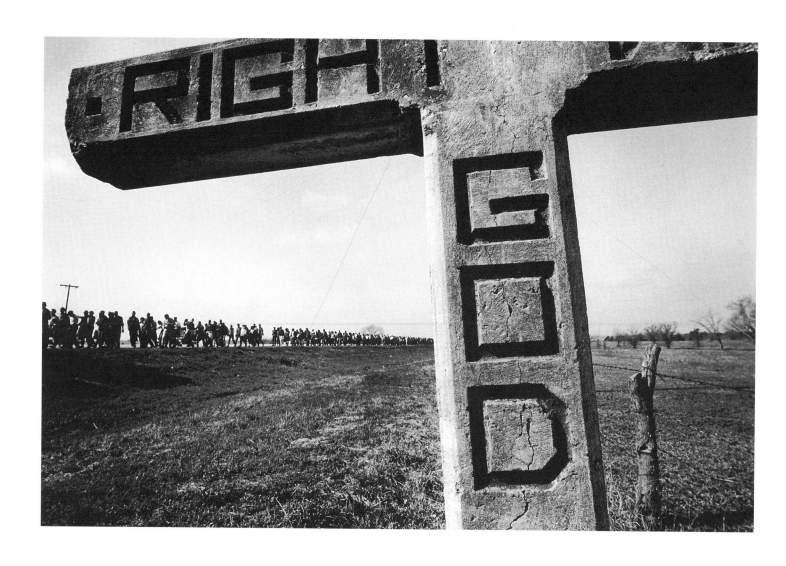

66. *"Get Right with God" Sign on Highway 80, Selma to Montgomery March, 1965*
9⅝ × 13⅝ inches (25 × 34.8 cm)
Vintage gelatin silver print
Estate of James Karales

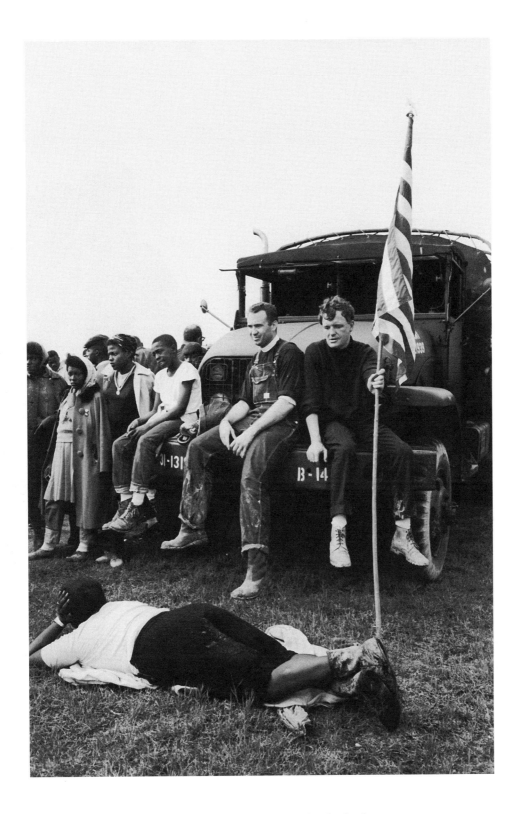

67. *Rev. Richard Dickerson, Disciples of Christ Missionary, and Richard Jackson,*
Labor Organizer, Seated on Truck (right), Taking a Break with Other Marchers, 1965
Digital scan from original 35mm negative
Rare Book, Manuscript, and Special Collections Library, Duke University

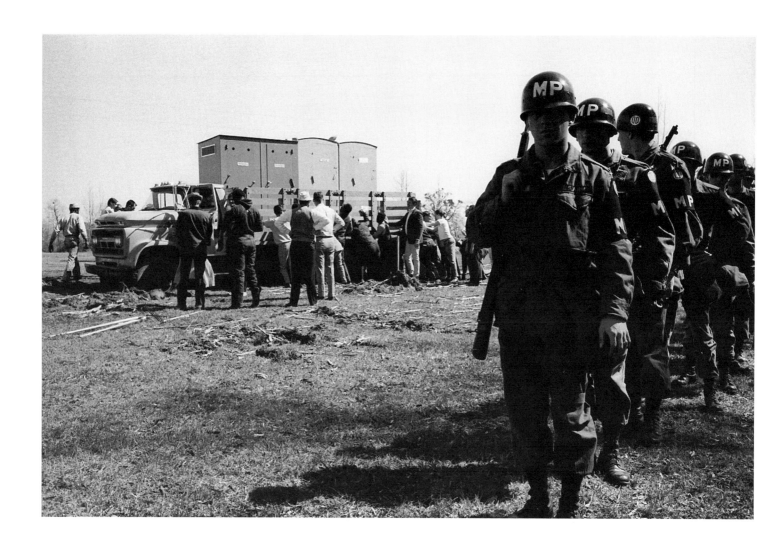

68. *Military Police Standing Guard during Delivery of Latrines for Marchers, 1965*
Digital scan from original 35mm negative
Rare Book, Manuscript, and Special Collections Library, Duke University

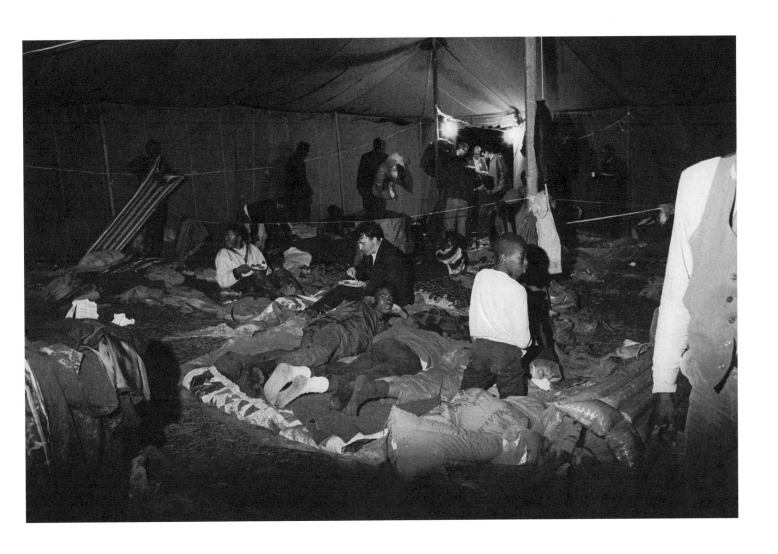

69. *Marchers Settling Down for the Night, Selma to Montgomery March, 1965*
Digital scan from original 35mm negative
Rare Book, Manuscript, and Special Collections Library, Duke University

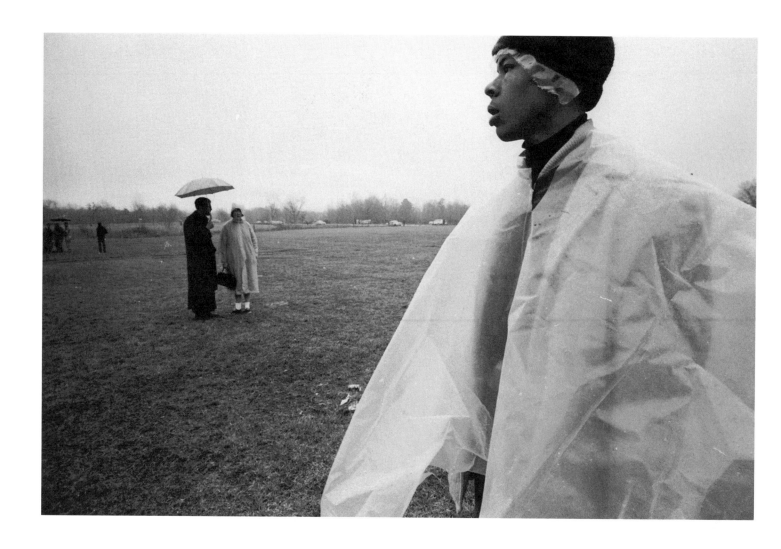

70. *Early Morning Campsite, Selma to Montgomery March, 1965*
Digital scan from original 35mm negative
Rare Book, Manuscript, and Special Collections Library, Duke University

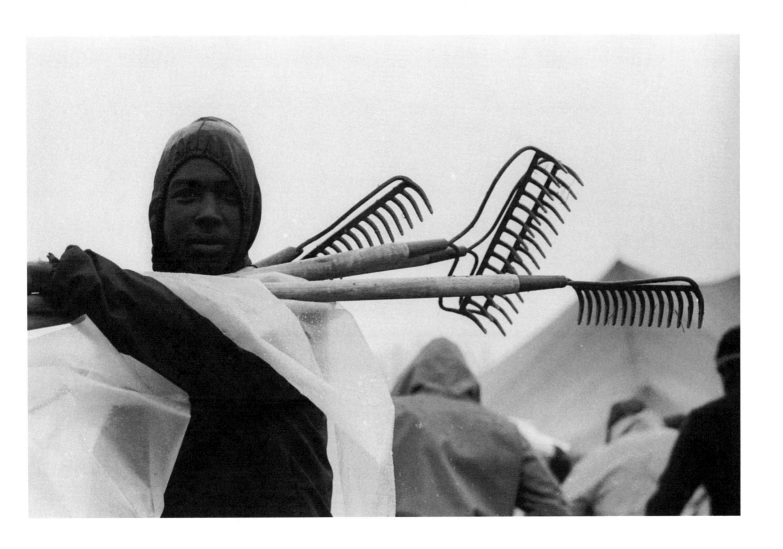

71. *Rain-Soaked Marcher, Selma to Montgomery March, 1965*
Digital scan from original 35mm negative
Rare Book, Manuscript, and Special Collections Library, Duke University

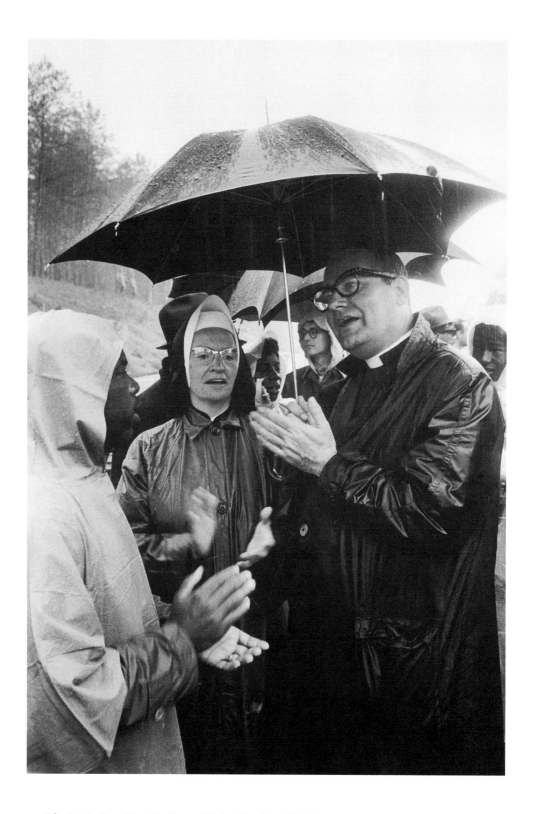

72. *John Lewis, Sister Mary Leoline, and Father Theodore Gill, Selma to Montgomery March, 1965*
7³/8 × 4⁷/8 inches (18.6 × 12.5 cm)
Vintage gelatin silver print
Estate of James Karales

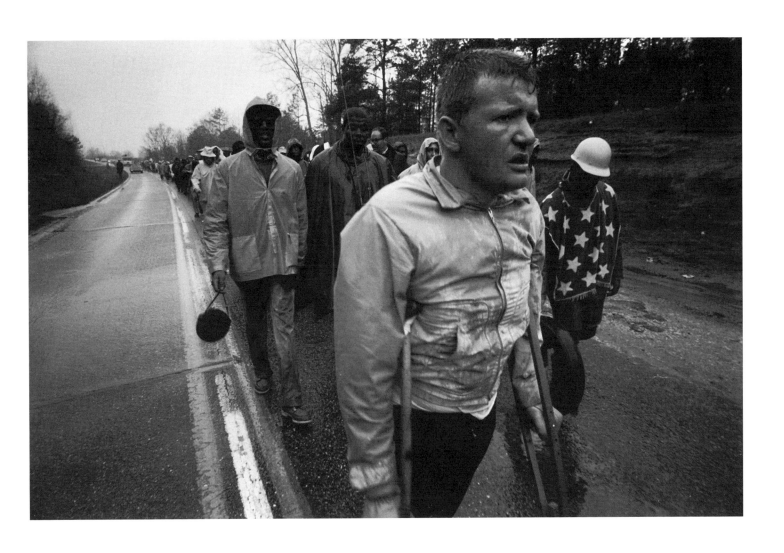

73. *Jim Letherer Leading Marchers, Selma to Montgomery March, 1965*
Digital scan from original 35mm negative
Rare Book, Manuscript, and Special Collections Library, Duke University

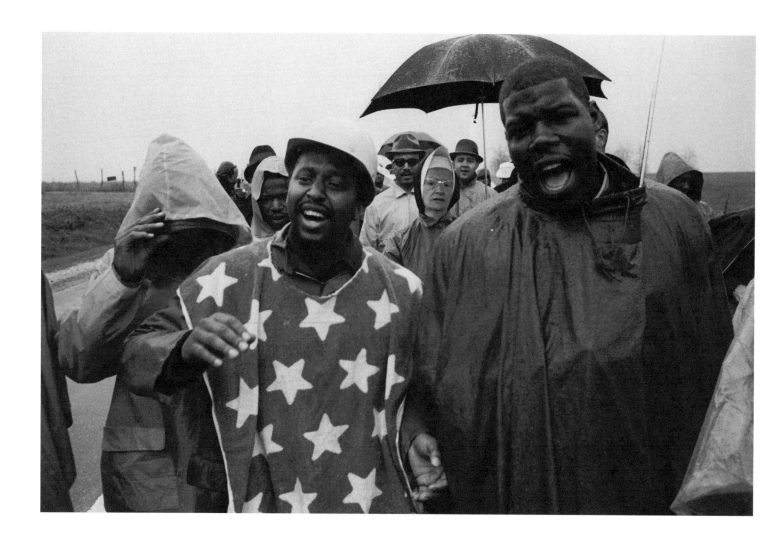

74. *Singing in the Rain, Selma to Montgomery March, 1965*
Digital scan from original 35mm negative
Rare Book, Manuscript, and Special Collections Library, Duke University

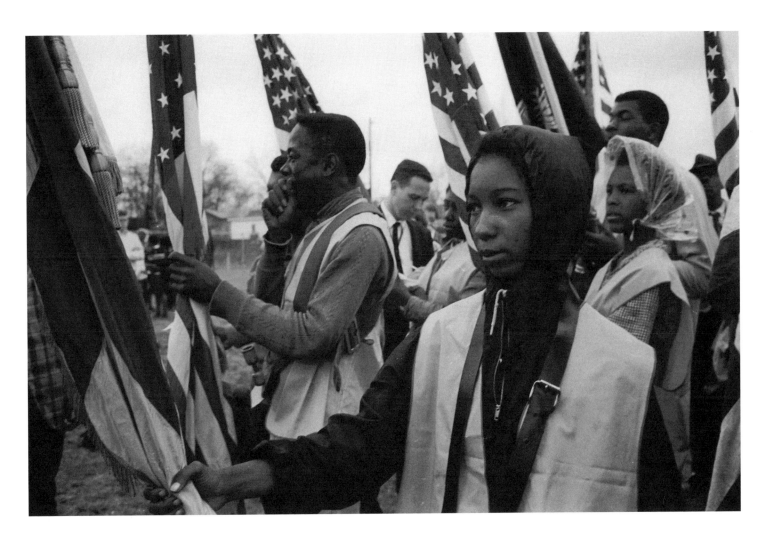

75. *Flag-Bearing Marchers, Selma to Montgomery March, 1965*
Digital scan from original 35mm negative
Rare Book, Manuscript, and Special Collections Library, Duke University

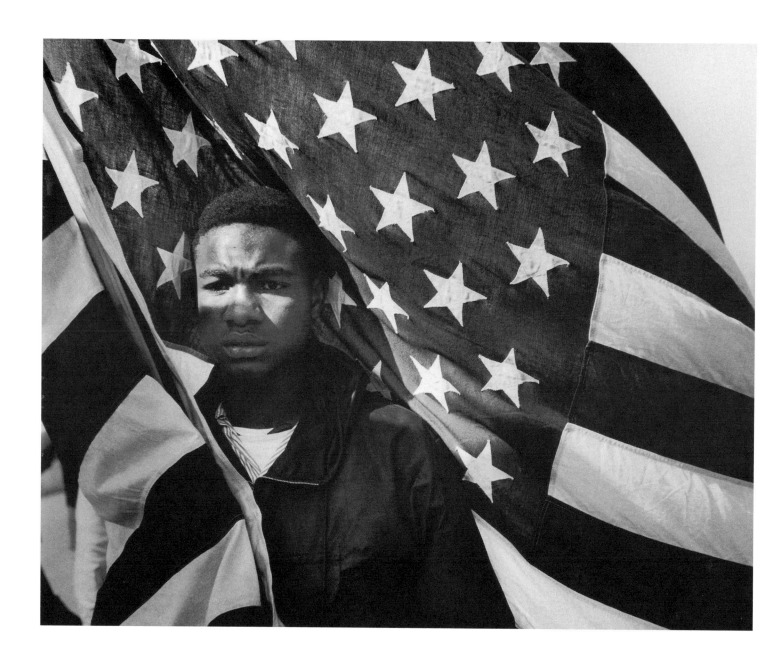

76. *Lewis "Big June" Marshall Carrying the U.S. Flag, Selma to Montgomery March, 1965*
7³⁄₄ × 9⁵⁄₈ inches (19.7 × 24.5 cm)
Vintage gelatin silver print
Estate of James Karales

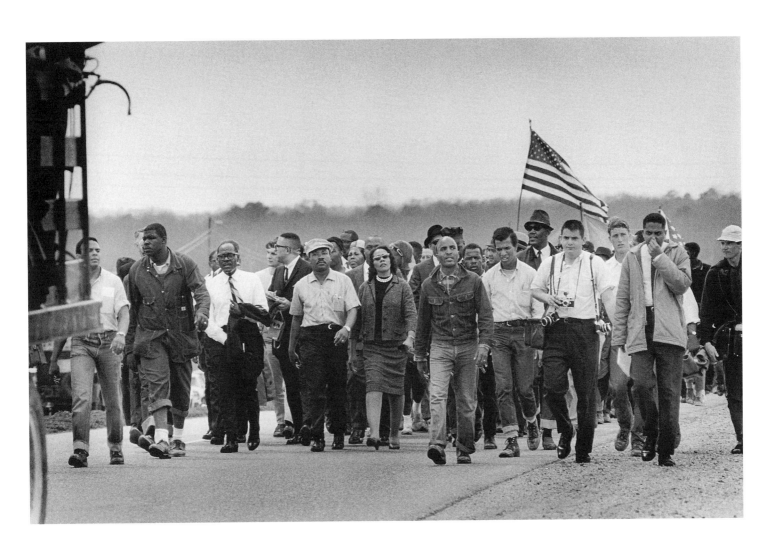

77. *Dr. Martin Luther King, Jr., and Other Civil Rights Leaders
on Highway 80, Selma to Montgomery March, 1965*
8 ¾ × 13 ¼ inches (22.2 × 22.7 cm)
Modern gelatin silver print
Estate of James Karales

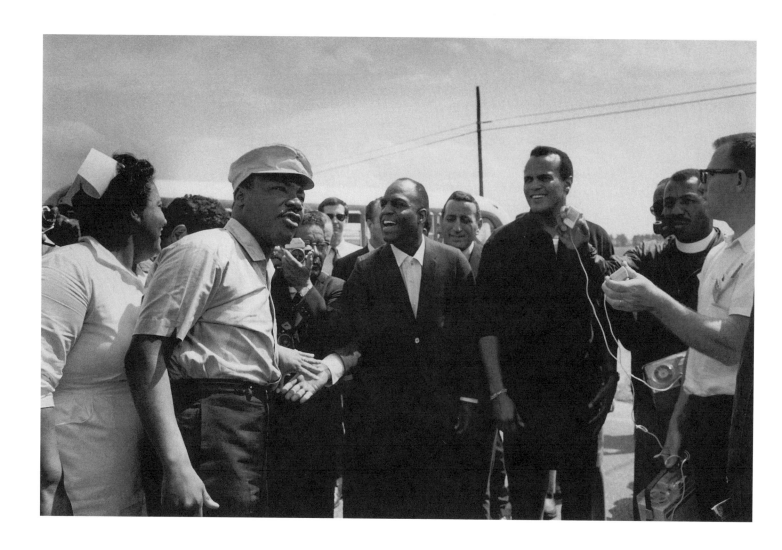

78. *Dr. Martin Luther King, Jr., Nipsy Russell, Tony Bennett, and*
Harry Belafonte Speaking with the Press, Selma to Montgomery March, 1965
8¾ × 13¼ inches (22.2 × 22.7 cm)
Modern gelatin silver print
Estate of James Karales

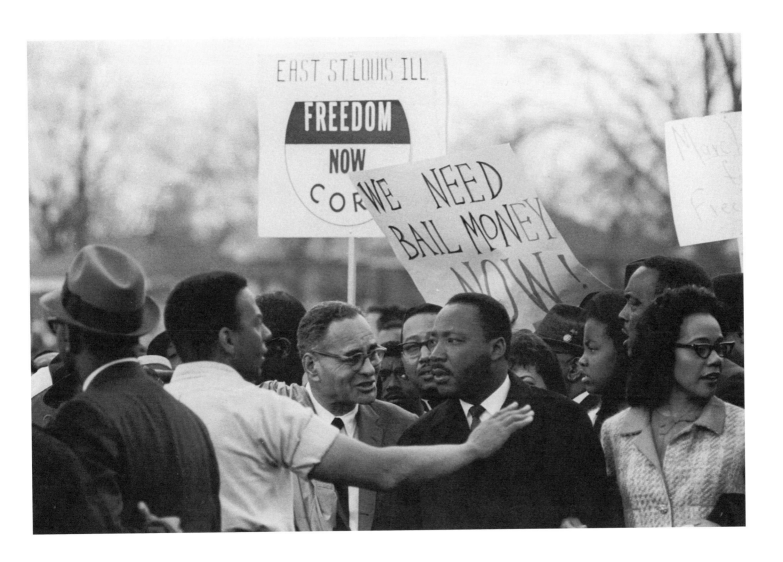

79. *Andrew Young Speaking to Ralph Bunche and Dr. Martin Luther King, Jr.,*
Selma to Montgomery March, 1965
Digital scan from original 35mm negative
Rare Book, Manuscript, and Special Collections Library, Duke University

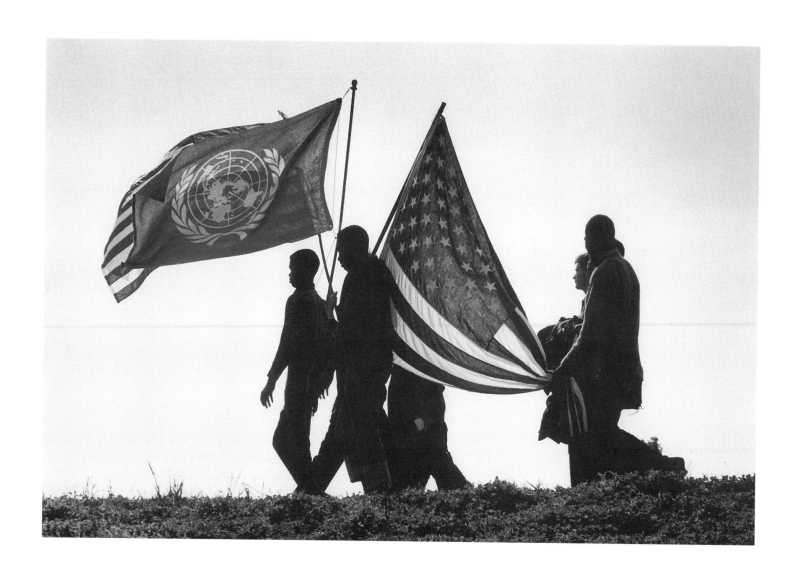

80. *Flag-Bearing Marchers, Selma to Montgomery March, 1965*
6½ × 9⅝ inches (16.7 × 24.4 cm)
Vintage gelatin silver print
Estate of James Karales

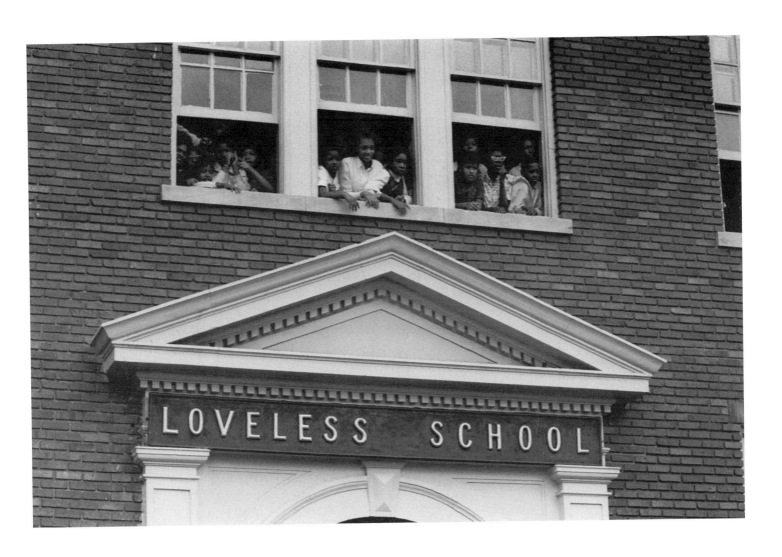

81. *Loveless School, Montgomery, 1965*
Digital scan from original 35mm negative
Rare Book, Manuscript, and Special Collections Library, Duke University

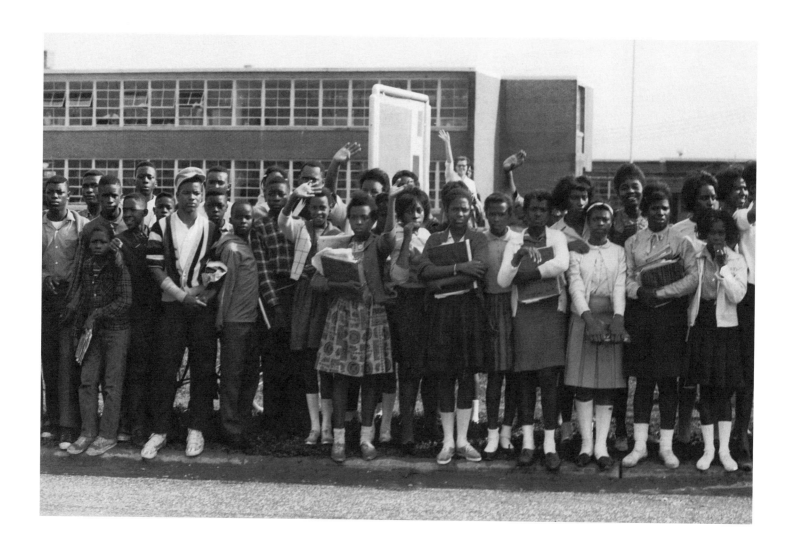

82. *Students Watching Marchers from the Sidewalk, Montgomery, 1965*
Digital scan from original 35mm negative
Rare Book, Manuscript, and Special Collections Library, Duke University

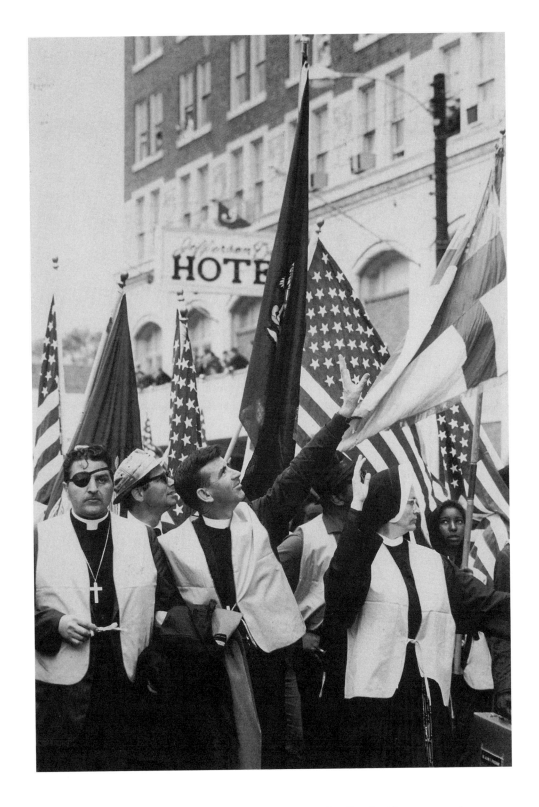

83. *Rev. Dominic Orsini, Rev. Arthur Matott, and Sister Mary Leoline Entering Montgomery, 1965*
9⅜ × 6⅜ inches (23.8 × 15.8 cm)
Vintage gelatin silver print
Estate of James Karales

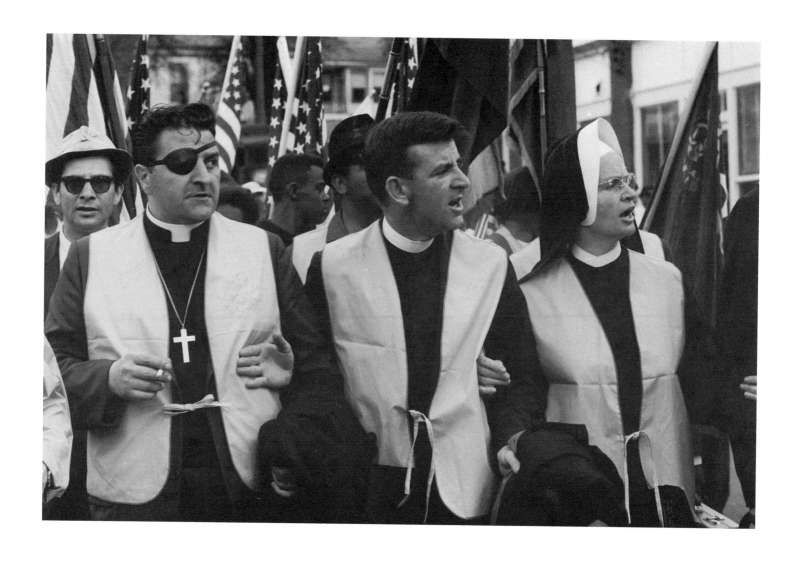

84. *Rev. Dominic Orsini, Rev. Arthur Matott, and Sister Mary Leoline Entering Montgomery, 1965*
Digital scan from original 35mm negative
Rare Book, Manuscript, and Special Collections Library, Duke University

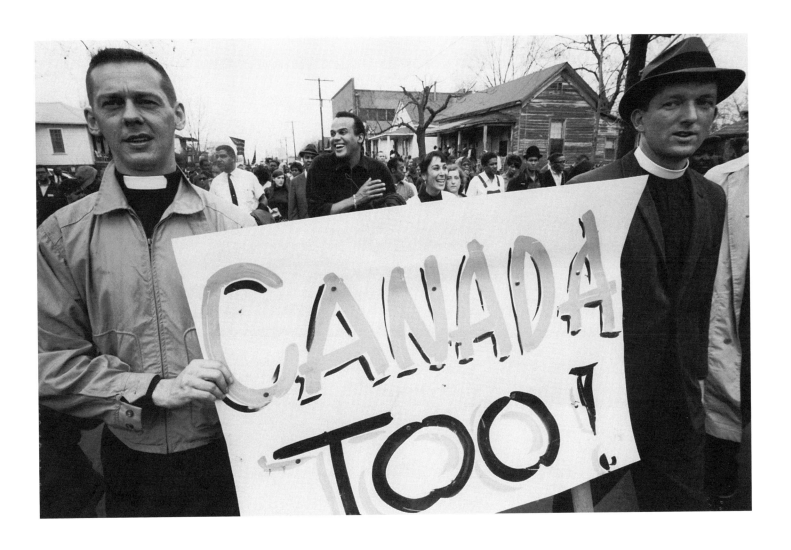

85. *Canadian Clergy Entering Montgomery, Selma to Montgomery March, 1965*
Digital scan from original 35mm negative
Rare Book, Manuscript, and Special Collections Library, Duke University

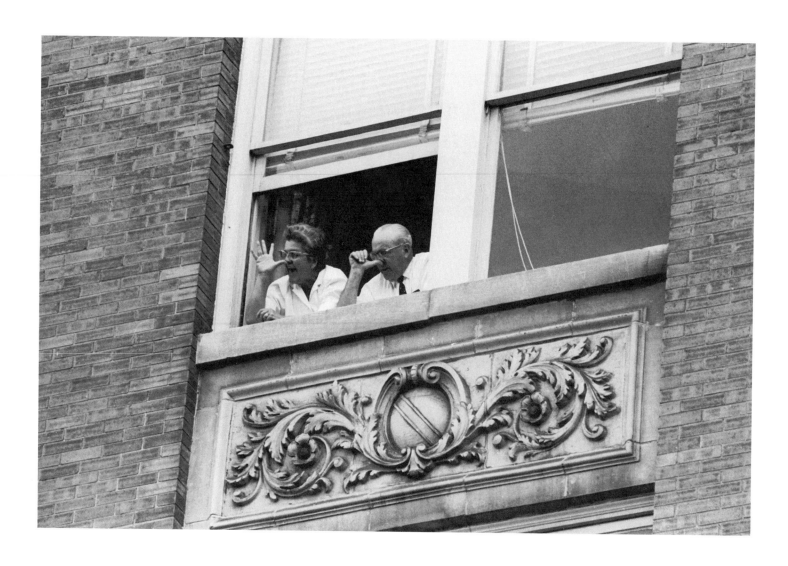

86. *Hostile Residents, Montgomery, 1965*
Digital scan from original 35mm negative
Rare Book, Manuscript, and Special Collections Library, Duke University

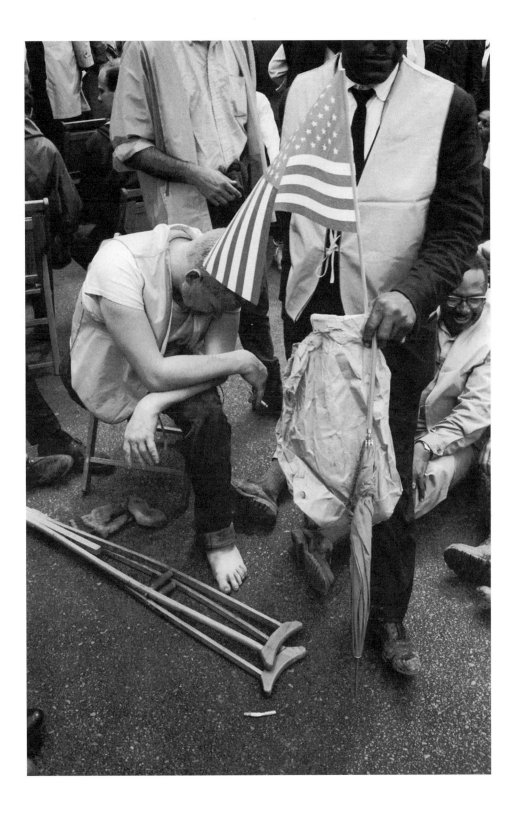

87. *Jim Letherer Resting at the Conclusion of the Selma to Montgomery March, 1965*
Digital scan from original 35mm negative
Rare Book, Manuscript, and Special Collections Library, Duke University

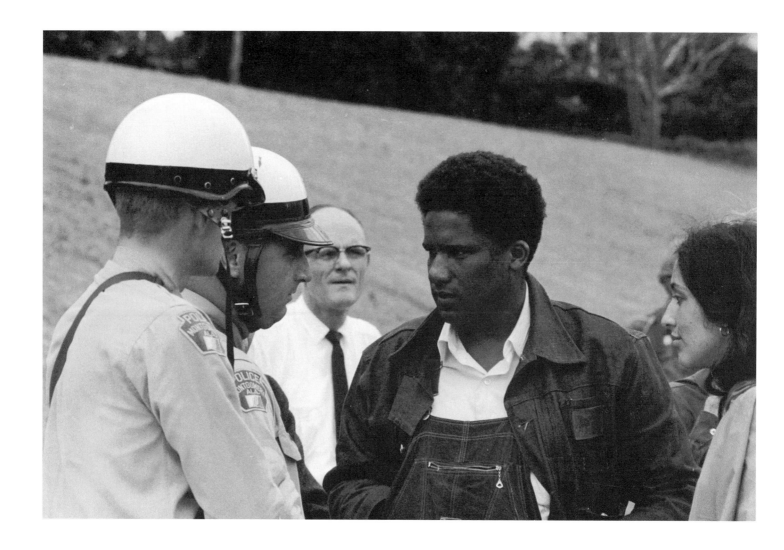

88. *James Forman and Joan Baez Talking with Police, Montgomery, 1965*
Digital scan from original 35mm negative
Rare Book, Manuscript, and Special Collections Library, Duke University

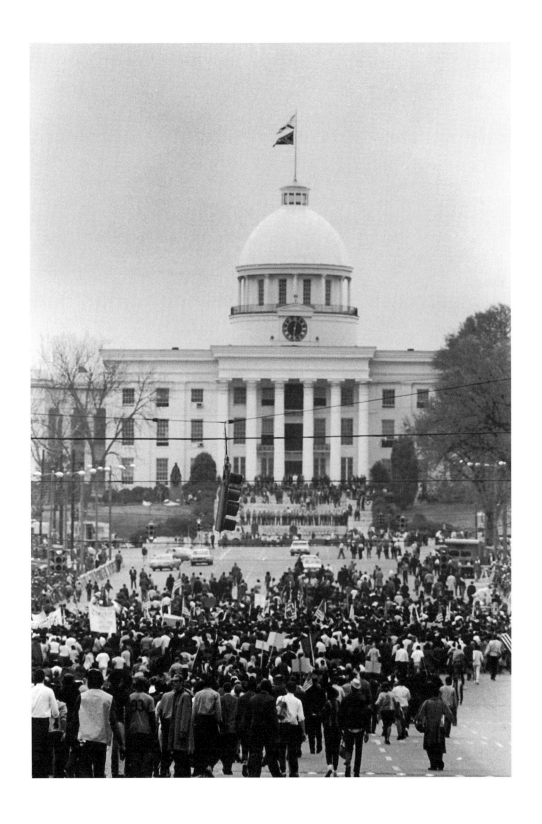

89. *Marchers Approaching the Alabama State Capitol, Montgomery, 1965*
Digital scan from original 35mm negative
Rare Book, Manuscript, and Special Collections Library, Duke University

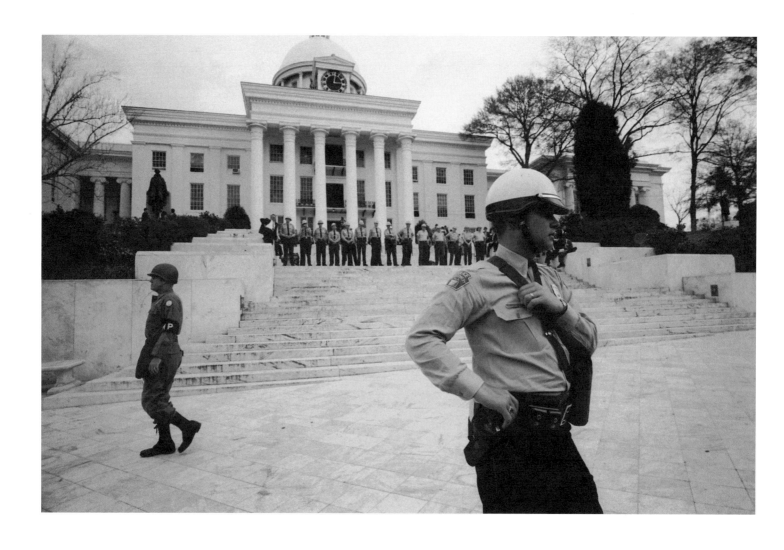

90. *Military Police and State Troopers Guarding the Alabama State Capitol, Montgomery, 1965*
Digital scan from original 35mm negative
Rare Book, Manuscript, and Special Collections Library, Duke University

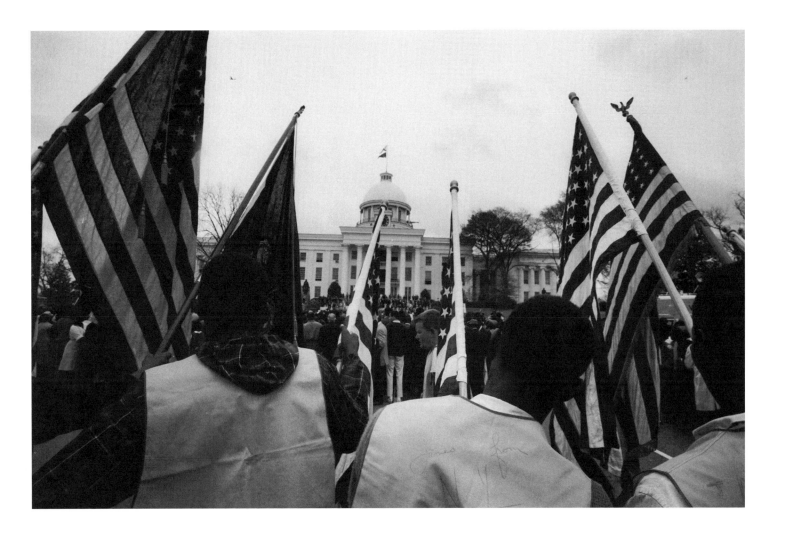

91. *Marchers Assembled in Front of the Alabama State Capitol, Montgomery, 1965*
4⅝ × 6⅞ inches (11.8 × 17.5 cm)
Vintage gelatin silver print
Estate of James Karales

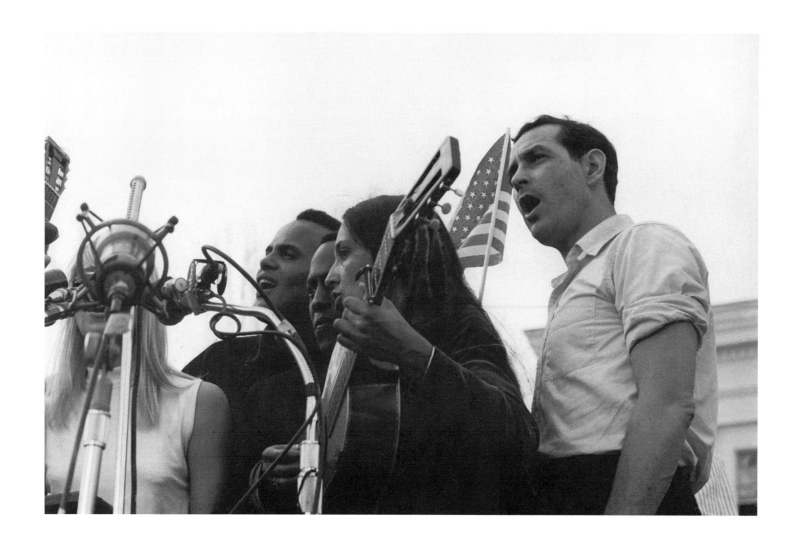

92. *Peter, Paul, and Mary Singing with Harry Belafonte, Oscar Brand, and Joan Baez, 1965*
Digital scan from original 35mm negative
Rare Book, Manuscript, and Special Collections Library, Duke University

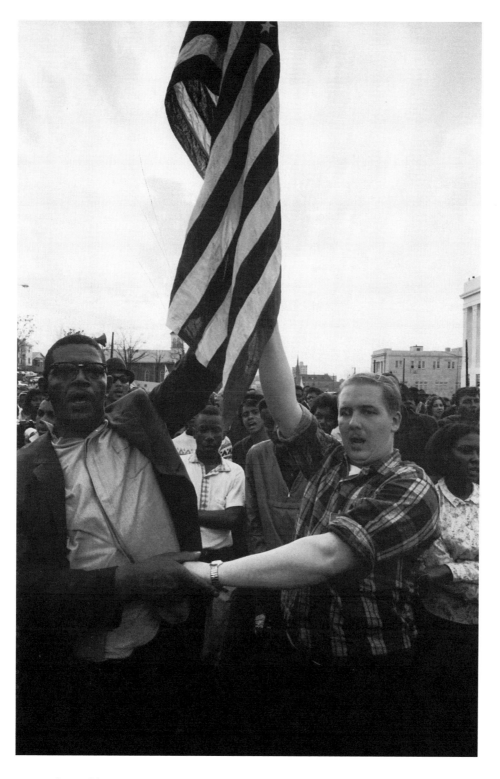

93. *Marchers Celebrating in Unity,*
Montgomery, 1965
16 3/4 × 12 1/8 inches (42.5 × 31 cm)
Vintage gelatin silver print
Estate of James Karales.

James Karales (seated) on the Lower East Side of New York, circa 1970–73.
Photographer unknown. Estate of James Karales.

Afterword

James Karales—A Compassionate Witness

Monica Karales

As the widow of James Karales, I, together with family and friends, have been touched by the significance of his legacy, and I am proud to share my thoughts with you.

James Karales witnessed and documented historic moments and met remarkable human beings such as the Reverend Dr. Martin Luther King, Jr. I feel honored that James Karales's photographs contribute to the important task of keeping alive the memory of this courageous crusader for peace, justice, and equality.

It was not just his artistic ability or his fine schooling that made this Greek American a successful photojournalist for *Look* magazine. His deep faith, the kindness of his heart, and his humble disposition allowed him to understand and have compassion for his fellow man. His innate gift for absorbing the stillness of a place or the drama of an event gave him the power to capture these feelings in his images.

"In order for a photographer to take more than ordinary pictures of people— more than convenient memories of those he knows well or of those he never met— he must feel a kinship with his subjects." These words by Carole Kismaric open the foreword of a book featuring James Karales's photographs of the Lower East Side in New York City in 1969. Kismaric comments: "The tradition of social documentation is strongly represented in the pictures by James Karales."

I believe that James discovered his calling to document the human condition early, while he was studying photography at Ohio University, and that his vocation stemmed from growing up in a minority community. Thus it is not surprising that his first photo-essay on Greek Americans is relevant to all his work.

James told me that, while working as an assistant to the great photojournalist W. Eugene Smith, he received praise from the master for his photo-essay on Rendville, Ohio. In the 1950s Rendville was one of the few racially integrated working communities in the nation, and James documented it extensively. When I first met James in 1973, he showed me his iconic Selma March photograph (plate 63), taken in 1965 while he was covering the March for Voting Rights from Selma to Montgomery, Alabama. I was moved to tears. I deeply felt the despair and determination of African Americans, who for so long have endured the cruelties of racial injustice.

I am convinced of the importance for the younger generation to see these images taken by a witness of the civil rights movement of the 1960s, so that they may be moved as I was. Only then, can we all fully grasp the struggle for racial justice for all Americans, and strive for authentic equality in the future.

In collaboration with the Rare Book, Manuscript, and Special Collections Library at Duke University, chosen as the repository of the James Karales archive, and as the custodian and executrix of his estate, I shall continue with my efforts to have his work more widely known through exhibitions and publications.

Selected Bibliography

Adelman, Bob, and Charles Johnson. *King: The Photobiography of Martin Luther King, Jr.* New York: Viking Studio 2000.

Albert, Peter J., and Ronald Hoffman, eds. *We Shall Overcome: Martin Luther King, Jr., and the Black Freedom Struggle.* New York: Da Capo Press, 1990.

Anderson, Jervis. *Bayard Rustin: Troubles I've Seen, a Biography.* New York: HarperCollins, 1997.

Arsenault, Raymond. *Freedom Riders: 1961 and the Struggle for Racial Justice.* Oxford & New York: Oxford University Press, 2006.

Ashmore, Harry S. *Civil Rights and Wrongs: A Memoir of Race and Politics, 1944–1996.* Revised and expanded edition. Columbia: University of South Carolina Press, 1997.

Associated Press. *Breaking News: How the Associated Press Has Covered War, Peace, and Everything Else.* New York: Princeton Architectural Press, 2007.

Bailey, Ronald W., and Michèle Furst, eds. *Let Us March On! Selected Civil Rights Photographs of Ernest C. Withers, 1955–1968.* Boston: Massachusetts College of Art, 1992.

Beals, Melba Pattillo. *Warriors Don't Cry: A Searing Memoir of the Battle to Integrate Little Rock's Central High.* New York: Washington Square Press, 1994.

Belfrage, Sally. *Freedom Summer.* Charlottesville & London: University Press of Virginia. 1990.

Berger, Maurice. *For All the World to See: Visual Culture and the Struggle for Civil Rights.* New Haven & London: Yale University Press, 2010.

Blumberg, Rhoda Lois. *Civil Rights: The 1960s Freedom Struggle.* Boston: Twayne, 1984.

Booker, Simeon. *Black Man's America.* Englewood Cliffs, N.J.: Prentice-Hall, 1964.

Branch, Taylor. *Parting the Waters: America in the King Years, 1954–63.* New York: Simon & Schuster, 1988.

———. *Pillar of Fire: America in the King Years, 1963–65.* New York: Simon & Schuster, 1998.

———. *At Canaan's Edge: America in the King Years, 1965–68.* New York: Simon & Schuster, 2006.

Brinkley, Douglas. *Rosa Parks.* New York: Viking, 2000.

Bullard, Sara, ed. *Free at Last: A History of the Civil Rights Movement and Those Who Died in the Struggle.* New York: Oxford University Press, 1993.

Cagin, Seth, and Philip Dray. *We Are Not Afraid: The Story of Goodman, Schwerner, and Chaney and the Civil Rights Campaign for Mississippi.* New York: Macmillan, 1988.

Carson, Clayborne. *In Struggle: SNCC and the Black Awakening of the 1960s.* Cambridge, Mass.: Harvard University Press, 1981.

Carson, Clayborne, David J. Garrow, Vincent Harding, and Darlene Clark Hine, eds. *Eyes on the Prize: A Reader and Guide.* New York: Penguin, 1987.

Chapnick, Howard. *Truth Needs No Ally: Inside Photojournalism.* Columbia: University of Missouri Press, 1994.

Chappell, David L. *Inside Agitators: White Southerners in the Civil Rights Movement.* Baltimore: Johns Hopkins University Press, 1994.

Cook, James Graham. *The Segregationists.* New York: Appleton-Century-Crofts, 1962.

Counts, Will, Will Campbell, Ernest Dumas, and Robert S. McCord. *A Life Is More than a Moment: The Desegregation of Little Rock's Central High.* Bloomington: Indiana University Press, 1999.

Cox, Julian. *Road to Freedom: Photographs of the Civil Rights Movement, 1956–1968.* Atlanta: High Museum of Art, 2008.

Crawford, Vicki L., Jacqueline Anne Rouse, and Barbara Woods, eds. *Women in the Civil Rights Movement: Trailblazers and Torchbearers, 1941–1965.* Bloomington & Indianapolis: Indiana University Press, 1993.

Davidson, Bruce. *Time of Change: Civil Rights Photographs, 1961–1965.* Los Angeles: St. Ann's Press, 2002.

Dittmer, John. *Local People: The Struggle for Civil Rights in Mississippi.* Urbana & Chicago: University of Illinois Press, 1994.

Eskew, Glenn T. *But for Birmingham: The Local and National Movements in the Civil Rights Struggle.* Chapel Hill: University of North Carolina Press, 1997.

Evans, Sara. *Personal Politics: The Roots of the Women's Liberation Movements in the Civil Rights Movement and the New Left.* New York: Knopf, 1979.

Fager, Charles E. *Selma: The March That Changed the South.* Boston: Beacon Press, 1985.

Fairclough, Adam. *To Redeem the Soul of America: The Southern Christian Leadership Conference and Martin Luther King, Jr.* Athens: University of Georgia Press, 1987.

Galphin, Bruce. *The Riddle of Lester Maddox: An Unauthorized Biography.* Atlanta: Camelot, 1968.

Garrow, David J. *Protest at Selma: Martin Luther King, Jr., and the Voting Rights Act of 1965.* New Haven & London: Yale University Press, 1978.

———. *The FBI and Martin Luther King, Jr.: from "Solo" to Memphis.* Harmondsworth, U.K. & New York: Penguin, 1983.

———. *Bearing the Cross: Martin Luther King, Jr., and the Southern Christian Leadership Conference.* New York: Vintage, 1988.

Gitlin, Todd. *The Sixties: Years of Hope, Days of Rage.* Toronto & New York: Bantam, 1987.

Greenberg, Howard, and Bob Shamis, eds. *James Karales.* New York: Howard Greenberg Gallery / Steidl, 2013.

Halberstam, David. *The Children.* New York: Random House, 1998.

Hampton, Henry, and Steven Fayer, eds. *Voices of Freedom: An Oral History of the Civil Rights Movement from the 1950s through the 1980s.* New York: Bantam, 1990.

Hansberry, Lorraine. *The Movement: Documentary of a Struggle for Equality.* New York: Simon & Schuster, 1964.

Harding, Vincent. *Hope and History: Why We Must Share the History of the Movement.* Maryknoll, N.Y.: Orbis, 1990.

Hunter-Gault, Charlayne. *In My Place.* New York: Farrar Straus Giroux, 1992.

Kasher, Steven. *The Civil Rights Movement: A Photographic History, 1954–68.* New York: Abbeville Press, 1996.

King, Martin Luther, Jr. *Stride toward Freedom: The Montgomery Story.* New York: Harper, 1958.

———. *Why We Can't Wait.* New York: Harper & Row, 1964.

———. *A Testament of Hope: The Essential Writings and Speeches of Martin Luther King, Jr.* Edited by James Melvin Washington. San Francisco: HarperCollins, 1991.

King, Mary. *Freedom Song: A Personal Story of the 1960s Civil Rights Movement.* New York: Morrow, 1987.

Kismaric, Carole. Foreword to *Exposure: Work by Ten Photographers.* New York: Creative Artists Public Service Program, 1976.

Kotz, Nick. *Judgment Days: Lyndon Baines Johnson, Martin Luther King, Jr., and the Laws That Changed America.* Boston: Houghton Mifflin, 2005.

Levine, Ellen, ed. *Freedom's Children: Young Civil Rights Activists Tell Their Own Story.* New York: Avon, 1994.

Levy, Peter B., ed. *Documentary History of the Modern Civil Rights Movement.* New York: Greenwood Press, 1992.

Lewis, Anthony. *Portrait of a Decade: The Second American Revolution.* New York: Random House, 1964.

Lewis, John, and Michael D'Orso. *Walking with the Wind: A Memoir of the Movement.* New York: Simon & Schuster, 1998.

Logue, Cal M. *Ralph McGill: Editor and Publisher.* 2 vols. Durham, N.C.: Moore, 1969.

Long, Worth W., Linn Shapiro, and Bernice Johnson Reagon. *We'll Never Turn Back.* Exhibition catalog. Washington, D.C.: Smithsonian Performing Arts, 1980.

Lyon, Danny. *Memories of the Southern Civil Rights Movement.* Chapel Hill: University of North Carolina Press, 1992.

Marable, Manning. *Race, Reform, and Rebellion: The Second Reconstruction in Black America, 1945–1982.* Jackson: University Press of Mississippi, 1984.

McAdam, Doug. *Freedom Summer.* New York: Oxford University Press, 1988.

McGill, Ralph. *The South and the Southerner*. Boston: Little, Brown, 1963.

McWhorter, Diane. *Carry Me Home: Birmingham, Alabama, the Climactic Battle of the Civil Rights Revolution*. New York: Simon & Schuster, 2001.

Meier, August, and Elliot Rudwick. *CORE: A Study in the Civil Rights Movement, 1942–1968*. Urbana: University of Illinois Press, 1975.

Meier, August, John Bracey, Jr., and Elliot Rudwick, eds. *Black Protest in the Sixties*. New York: Markus Wiener, 1991.

Meredith, James. *Three Years in Mississippi*. Bloomington: Indiana University Press, 1966.

Merrill, Linda, Lisa Rogers, and Kay Passmore. *Picturing America*. Washington, D.C.: National Endowment for the Arts, 2007.

Mills, Kay. *This Little Light of Mine: The Life of Fannie Lou Hamer*. New York: Dutton, 1993.

Moody, Anne. *Coming of Age in Mississippi*. New York: Dell, 1968.

Morris, Aldon D. *The Origins of the Civil Rights Movement: Black Communities Organizing for Change*. New York: Free Press, 1984.

Murray, Paul T. *The Civil Rights Movement: References and Resources*. New York: G. K. Hall, 1993.

Oppenheimer, Martin. *The Sit-In Movement of 1960*. Brooklyn: Carlson, 1989.

Partridge, Elizabeth. *Marching for Freedom: Walk Together, Children, and Don't You Grow Weary*. New York: Viking, 2009.

Peck, James. *Freedom Ride*. New York: Simon & Schuster, 1962.

Powledge, Fred. *Free at Last? The Civil Rights Movement and the People Who Made It*. Boston: Little, Brown, 1991.

Raines, Howell. *My Soul Is Rested*. Harmondsworth, U.K. & New York: Penguin, 1983.

Randall, Herbert, and Bobs M. Tusa. *Faces of Freedom Summer*. Tuscaloosa & London: University of Alabama Press, 2001.

Roberts, Gene, and Hank Klibanoff. *The Race Beat: The Press, the Civil Rights Struggle, and the Awakening of a Nation*. New York: Knopf, 2006.

Robinson, Jo Ann Gibson. *The Montgomery Bus Boycott and the Women Who Started It*. Knoxville: University of Tennessee Press, 1987.

Romano, Renee C., and Leigh Raiford, eds. *The Civil Rights Movement in American Memory*. Athens & London: University of Georgia Press, 2006.

Rowe, Gary Thomas, Jr. *My Undercover Years with the Ku Klux Klan*. New York: Bantam, 1976.

Schulke, Flip. *He Had a Dream: Martin Luther King, Jr., and the Civil Rights Movement*. New York: Norton, 1995.

———, ed. *Martin Luther King, Jr.: A Documentary, Montgomery to Memphis*. New York: Norton, 1976.

Seeger, Pete, and Bob Reiser. *Everybody Says Freedom*. New York: Norton, 1989.

Sitkoff, Harvard. *The Struggle for Black Equality, 1954–1980*. New York: Hill & Wang, 1981.

Sokol, Jason. *There Goes My Everything: White Southerners in the Age of Civil Rights, 1945–1975*. New York: Knopf, 2006.

Weisbrot, Robert. *Freedom Bound: A History of America's Civil Rights Movement*. New York: Plume, 1991.

Whitfield, Stephen J. *A Death in the Delta: The Story of Emmett Till*. New York: Free Press, 1988.

Williams, Juan. *Eyes on the Prize: America's Civil Rights Years, 1954–1965*. New York: Viking, 1987.

Withers, Ernest C. *I Am a Man: Photographs of the 1969 Memphis Sanitation Strike and Dr. Martin Luther King, Jr.* Memphis: Memphis Publishing, 1993.

Young, Andrew. *An Easy Burden: The Civil Rights Movement and the Transformation of America*. New York: HarperCollins, 1996.

Zinn, Howard. *SNCC: The New Abolitionists*. Boston: Beacon Press, 1964.